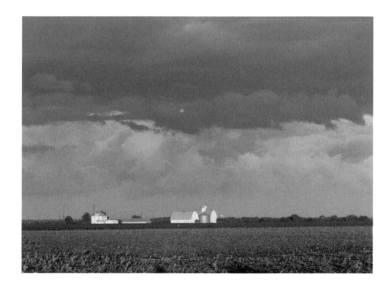

ILLINOIS

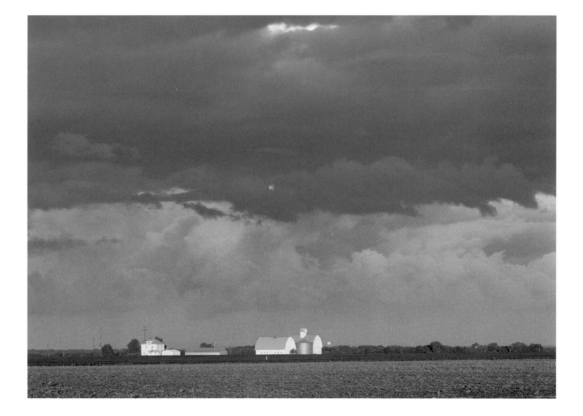

WHITECAP BOOKS

Text by Tanya Lloyd Kyi
Edited by Elaine Jones
Photo editing by Tanya Lloyd Kyi
Proofread by Lisa Collins
Cover and interior layout by Jacqui Thomas

Printed and bound in Canada

National Library of Canada Cataloguing in Publication Data

Kyi, Tanya Lloyd, 1973–

 Illinois

 (America series)
 ISBN 1-55285-326-8

 1. Illinois—Pictorial works. I. Title. II. Series: Kyi, Tanya Lloyd, 1973- America series.
F542.K94 2002 977.3'044'0222 C2002-910074-7

The publisher acknowledges the support of the Canada Council and the Cultural
Services Branch of the Government of British Columbia in making this publication
possible. We acknowledge the financial support of the Government of Canada through
the Book Publishing Industry Development Program for our publishing activities.

For more information on the America Series and other Whitecap Books
titles, please visit our web site at www.whitecap.ca.

About 1,000 years ago, Illinois was the site of a great city, possibly the largest north of Mexico. In the region modern archeologists have christened Cahokia, more than 20,000 people inhabited a six-mile radius, building homes in neat rows around large central plazas. Here, residents gathered for religious rituals, sporting events, and perhaps markets where farmers displayed the crops grown just outside the wooden city walls.

Historians continue to explore Cahokia and 10,000 other sites across the state, searching for clues to the rise and fall of an ancient civilization. Did climate change force the inhabitants to leave? War? Whatever the reason, the grasslands of Illinois remained, eventually hiding all traces of the cities and beckoning new arrivals. First the Illiniwek hunted and farmed the plains. Then, after the arrival of French trader Louis Joliet and missionary Jacques Marquette in 1673, Illinois began to draw attention from the wider world. By the end of the 1600s, fur-trading forts marked the confluences of rivers and trading routes, missions coexisted with native villages, and colonists in ox-drawn wagons steered toward the plains.

The farmers who arrived here saw the land much as the Cahokia people did centuries before—acres of fertile soil, crisscrossed by fresh water and dotted with hospitable valleys. On such land, one could build a successful family, a successful farm, perhaps even a successful society. So thought many soldiers who came here after the War of 1812, settling the southern forests that reminded them of their New England homes.

In 1818, Illinois became the twenty-first state, yet this didn't stop the search for a better society. In the 1840s, hundreds of Swedish immigrants followed Eric Janson to a communal settlement at Bishop Hill. Quaker and Mennonite colonies on the grasslands flourished. Mormons settled in Nauvoo from 1839 to 1846. In Zion, a Christian theocracy thrived until the 1930s.

Today only remnants of these attempts at utopia survive. Yet they have left behind a sense of optimism and idealism that permeates the practical farming communities of modern times. These farms, along with the cosmopolitan streets of Chicago, mingle with the legacy of the Cahokia farmers, the early colonists, and the promise-seekers, to create a unique state of mind in a unique state—Illinois.

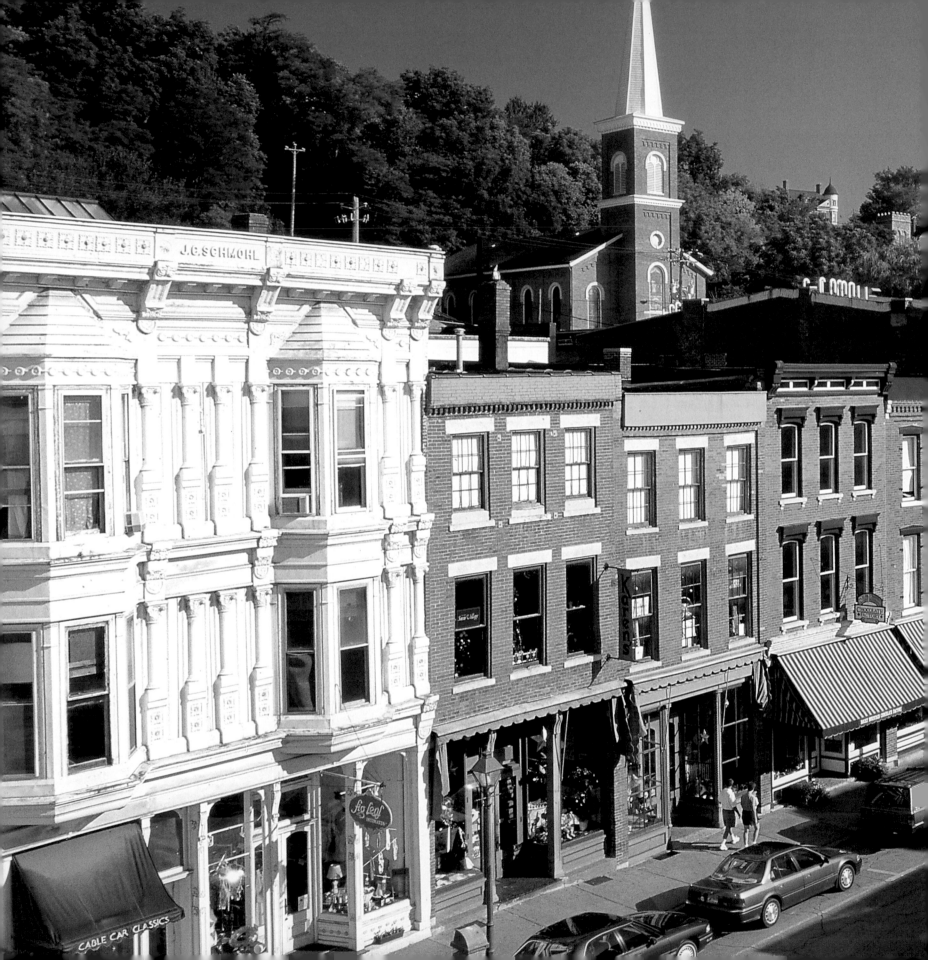

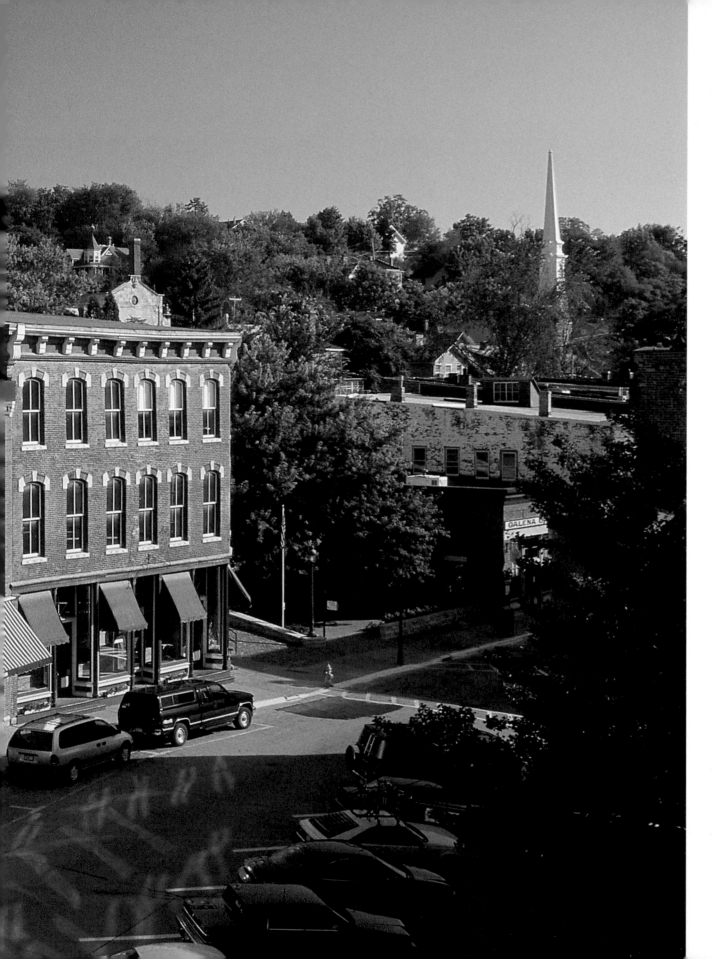

The elegant streets of Galena date from the glory days of mining; about 85 percent of the community's structures are listed in the National Register of Historic Places. The community was founded in 1826 when lead was discovered in the nearby hills.

7

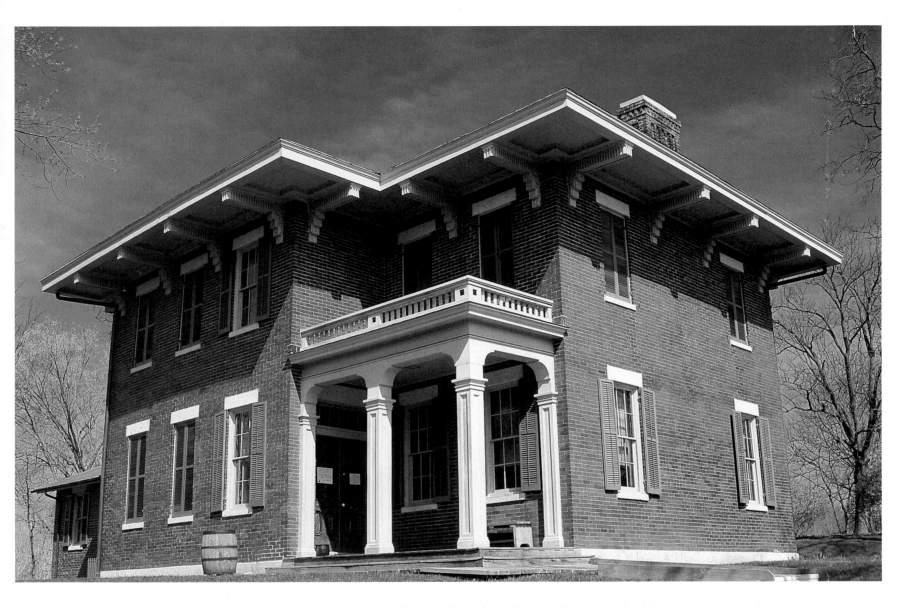

During the Civil War, Ulysses S. Grant led his troops to decisive victories and engineered the surrender of General Robert E. Lee. Grant returned to his hometown, Galena, a national hero and was presented with this stately home.

From the recreation areas along the Mississippi River to the parks of Shawnee National Forest, Illinois offers 270 trails totaling more than 700 miles.

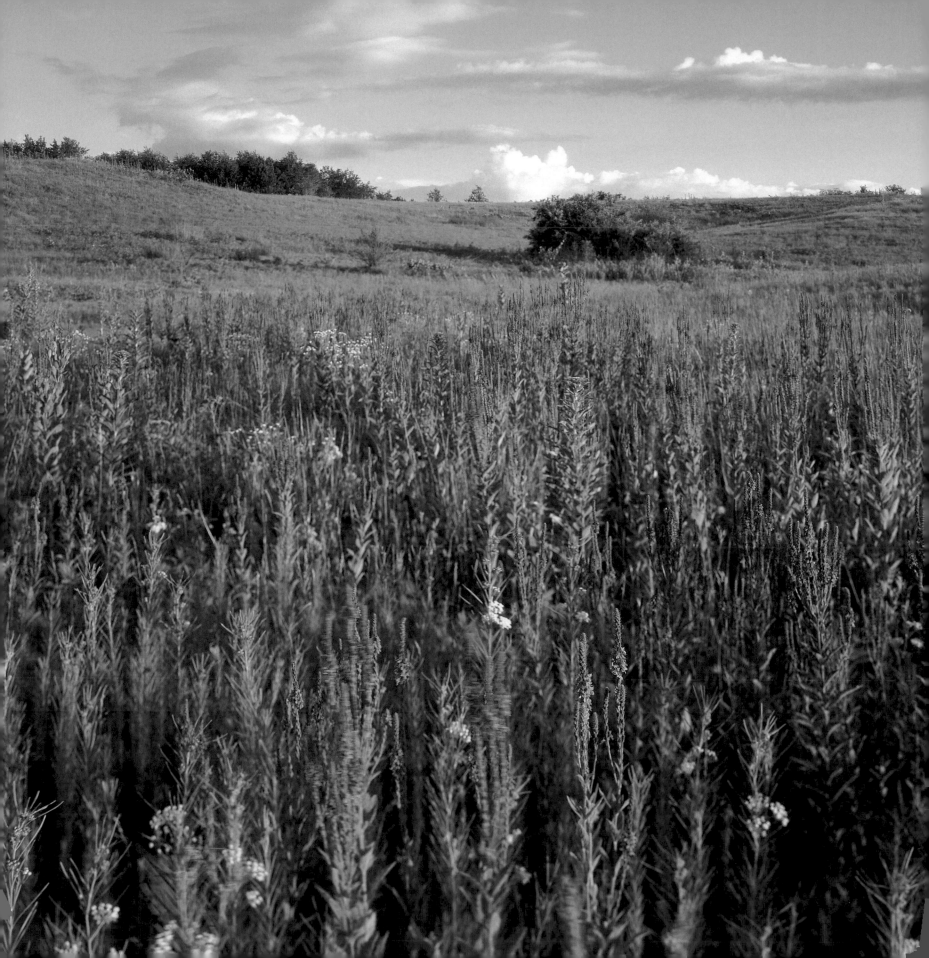

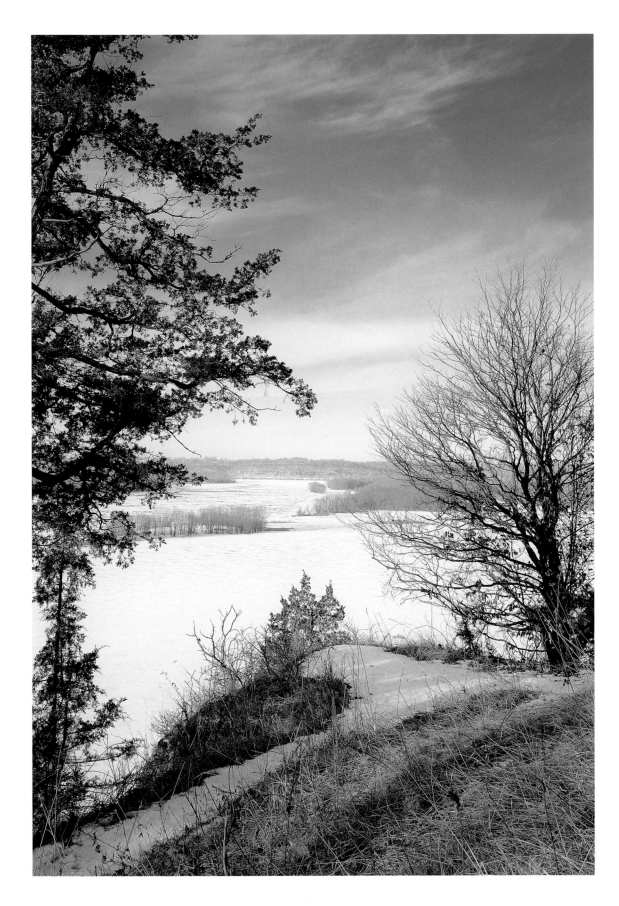

In summer, the cliffs of Mississippi Palisades State Park attract rock climbers and the river below offers anglers catfish, northern pike, and walleye. In winter, temperatures drop to 10 to 12°F, and the western border of the state becomes a ribbon of ice and snow.

FACING PAGE—
The rocky outcroppings that dot Nachusa Grasslands discouraged early farmers, thus saving the native prairie plant species from the plow. In 1986, minutes before the area was to be auctioned to home builders, the Nature Conservancy purchased the grasslands, now a growing preserve of more than 1,200 acres.

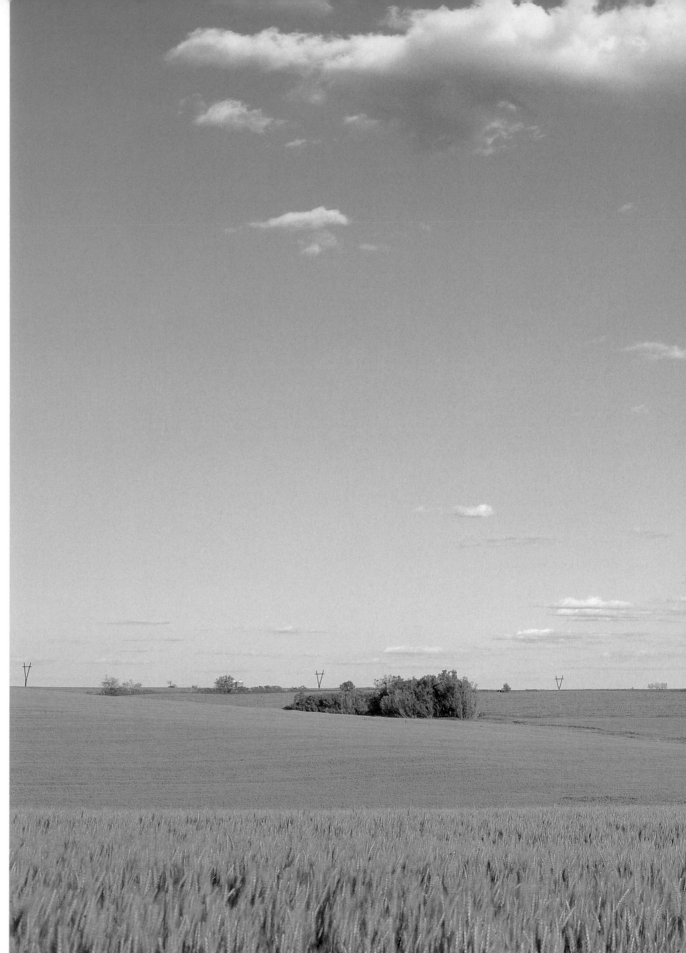

In 1817, the United States government began rewarding veterans from the War of 1812 with plots of farmland east of the Mississippi River. A year later, Illinois became the twenty-first state. By 1819, some of the homesteaders had banded together to form a state agricultural association.

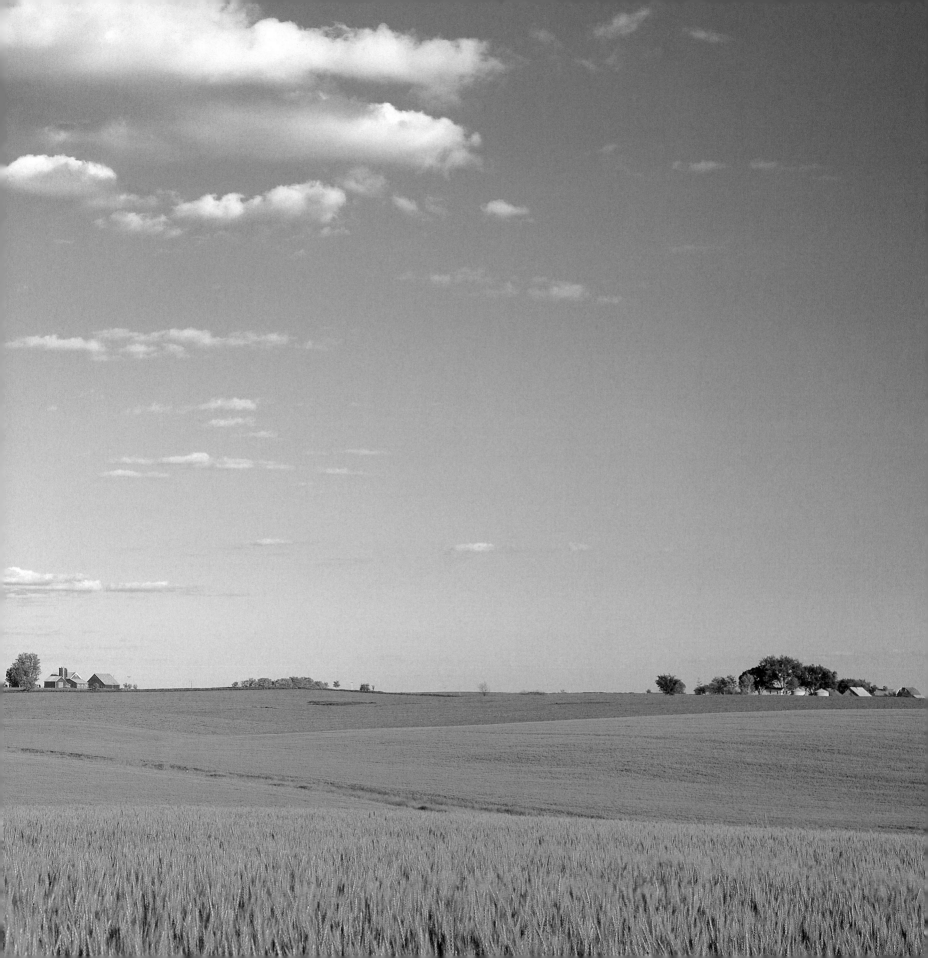

In the mid-1800s, the land that is now Franklin Creek State Park was an oasis of rich soil and abundant water in the midst of the dry prairie. Pioneer families farmed the valleys, built their homesteads from the abundant hardwoods, and harnessed the swiftest streams for grist mills.

FACING PAGE—
In early spring, germinating soybeans poke through the rich black soil of Lee County. Illinois produces almost 460 million bushels of soybeans each year, more than any other state in the nation.

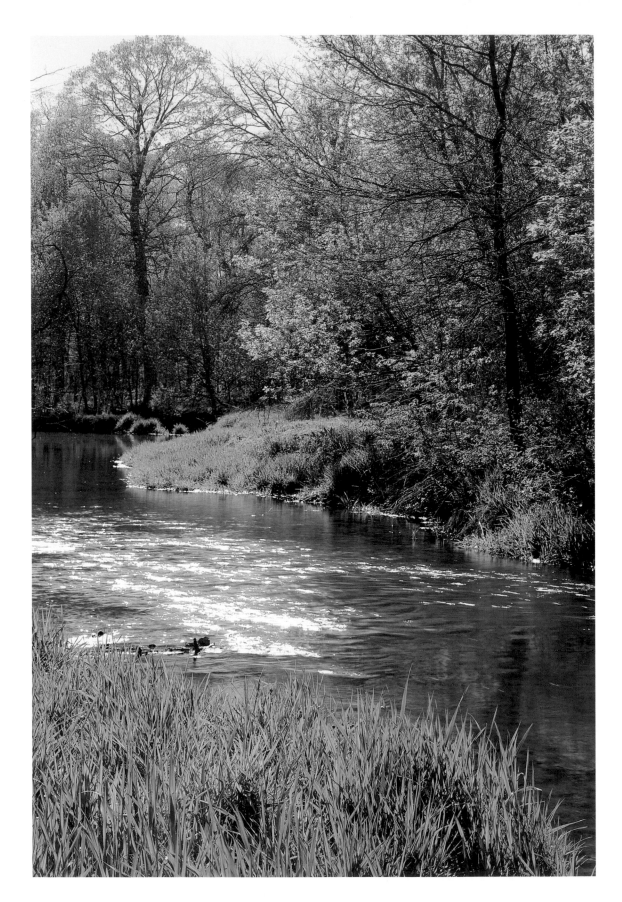

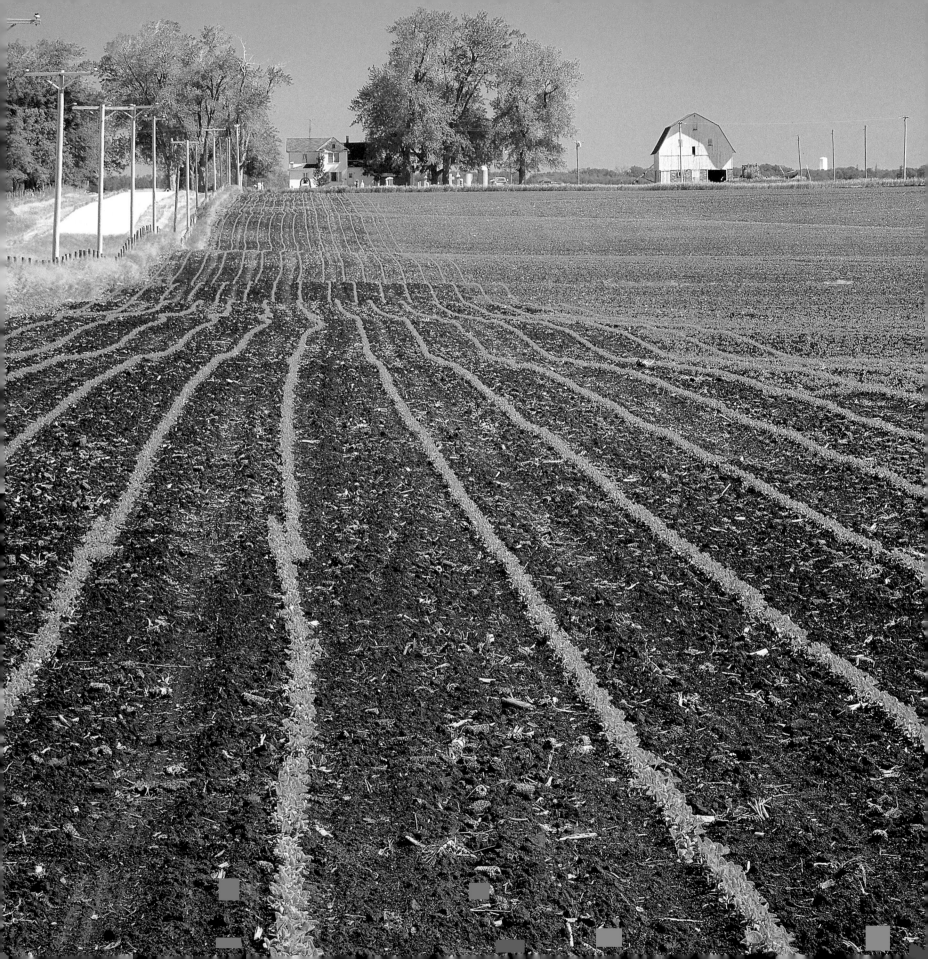

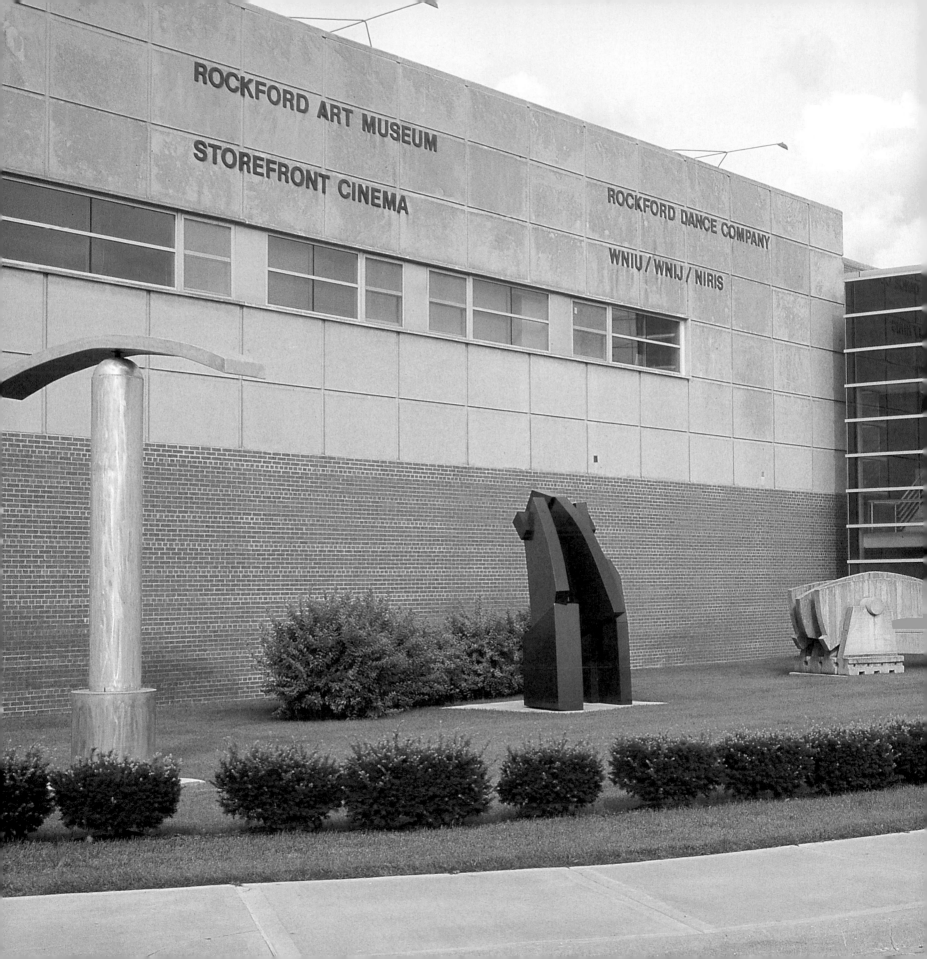

For more than a century, Geneva has been the commercial and cultural center for the surrounding region. By 1840, the community had built a post office, a jail, a school, a sawmill, three general stores, and two hotels. The present courthouse building was constructed in the 1890s.

Rockford's Riverfront Museum Park is home to two museums, a dance company, an orchestra, a radio station, and a cinema. As the second-largest city in the state, Rockford is a growing destination for conventions, sports events, and cultural activities.

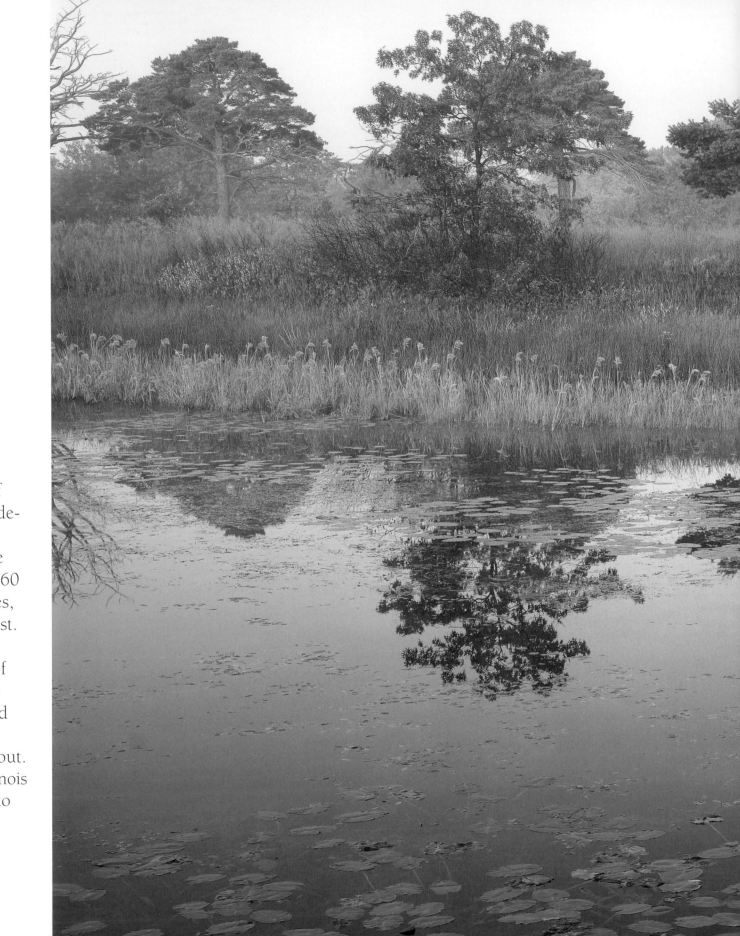

Protecting some of the state's only undeveloped shoreline, Illinois Beach State Park embraces 4,160 acres of sand dunes, wetlands, and forest. Dead River, in the southern section of the park, supports coho, chinook, and Atlantic salmon as well as rainbow trout. This is the only Illinois river that flows into the Great Lakes.

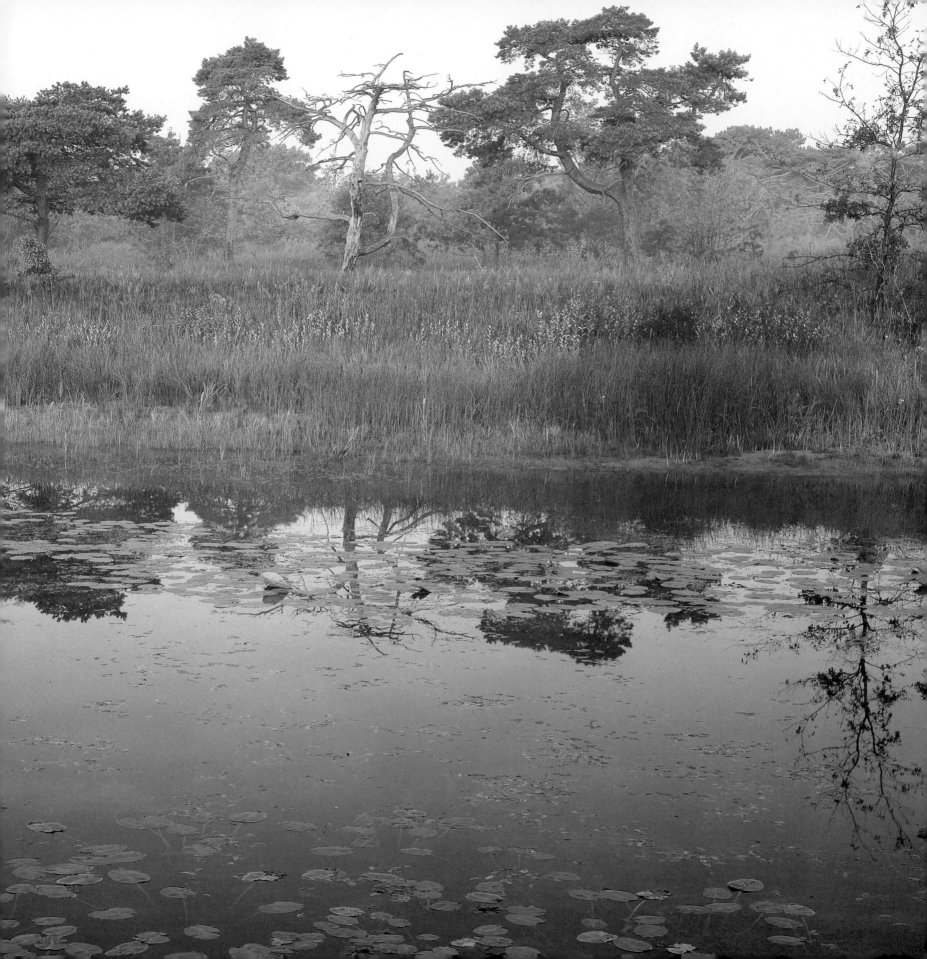

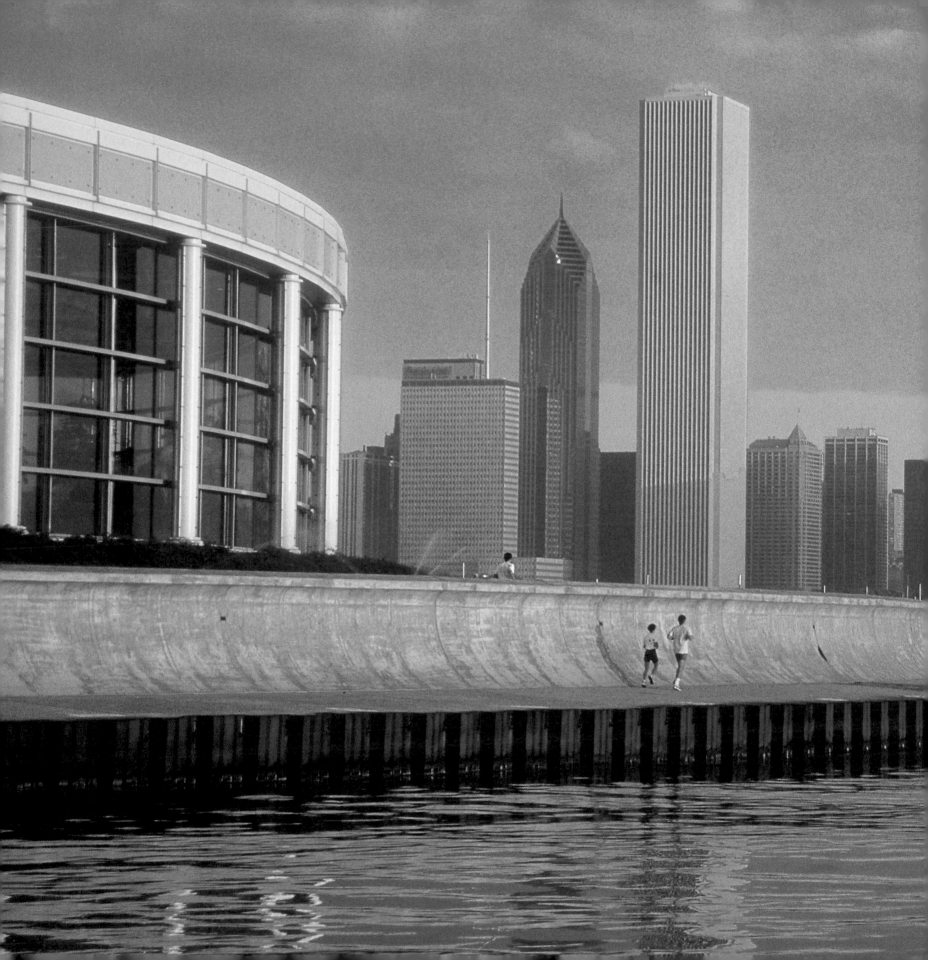

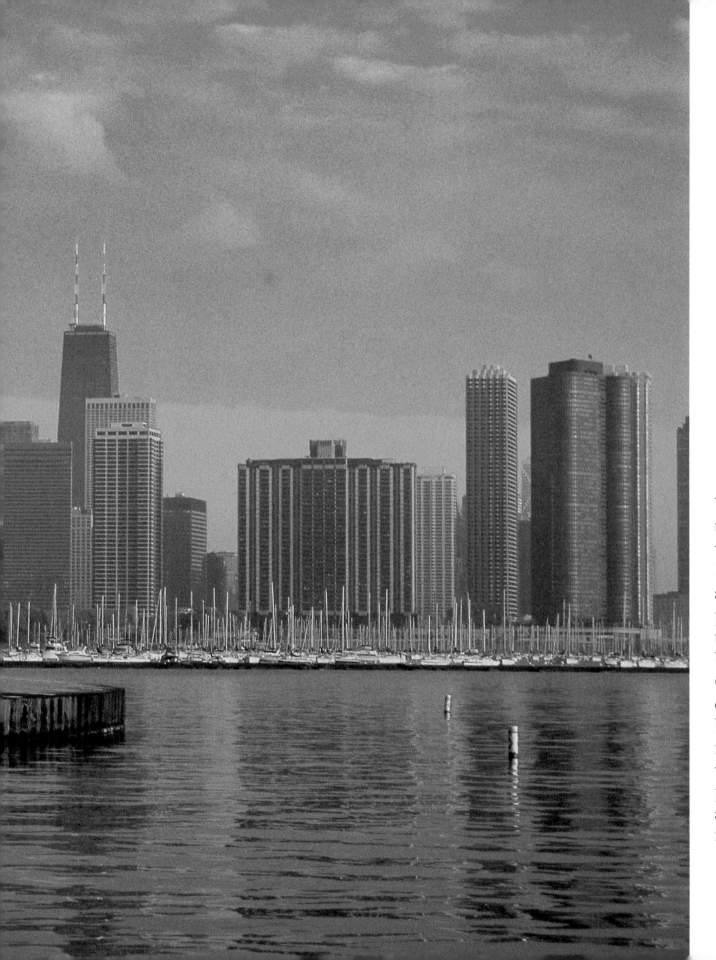

With 350 residents, the Town of Chicago was incorporated in 1833 on the site of a French fur-trading post. Four years later, the community had boomed to 4,170 and Chicago became a city. The population ballooned again, to more than 12,000, when builders completed the Illinois and Michigan canal in 1848.

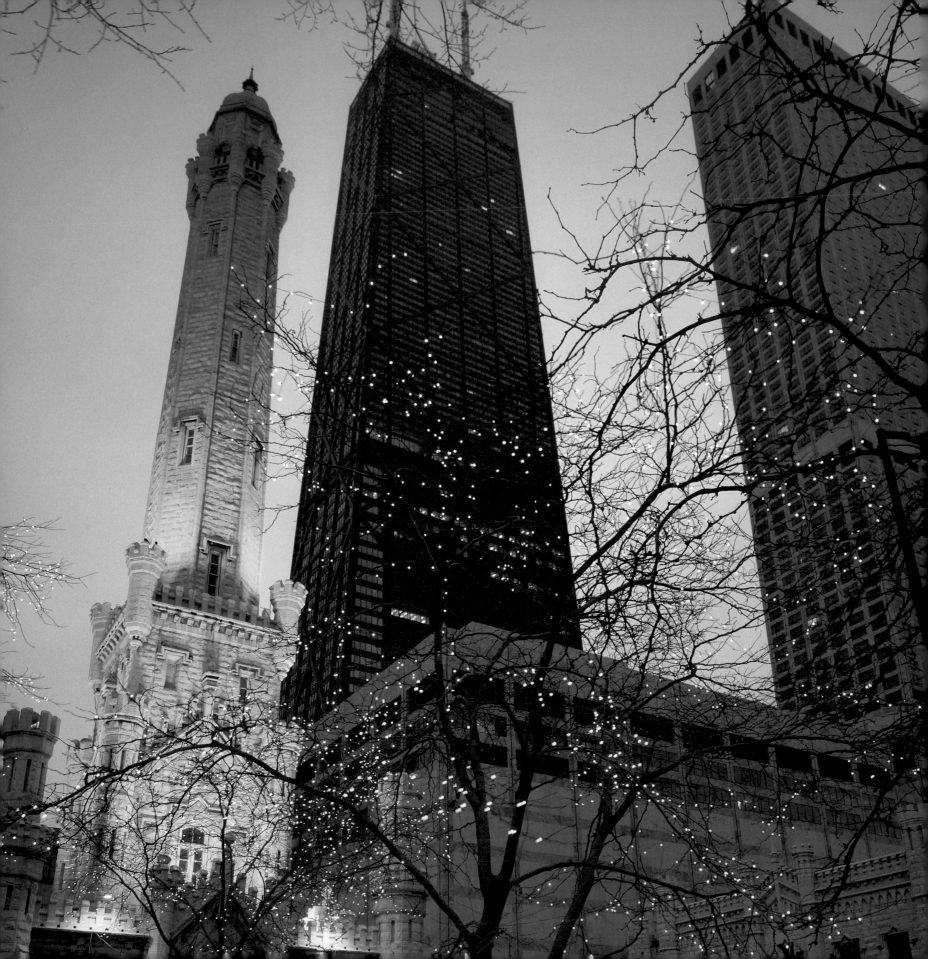

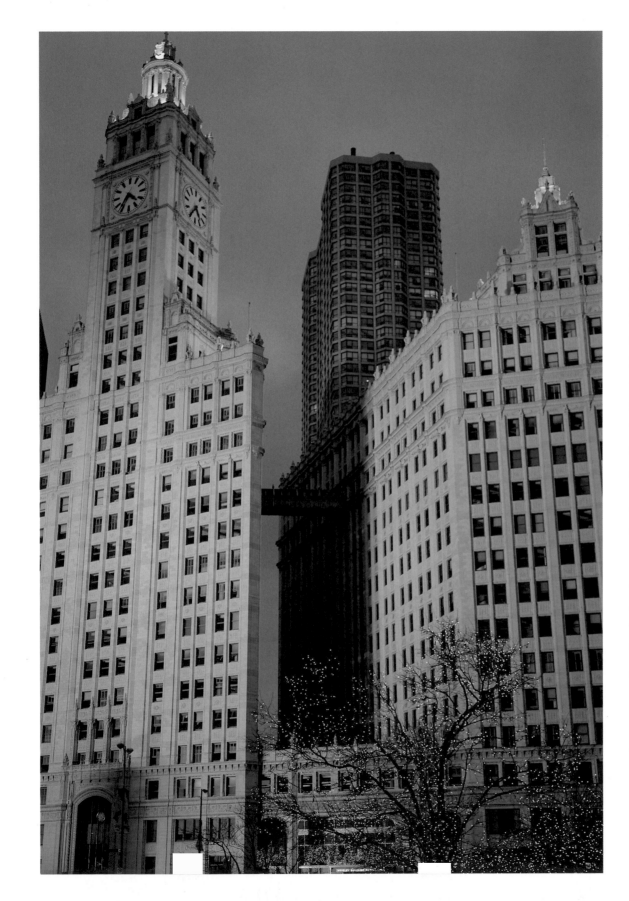

One of Chicago's most recognizable landmarks, the Wrigley Building was the vision of William Wrigley, best known as the founder of a chewing gum empire. It was completed in 1922. From the Wrigley Corporation's head offices, still housed in this building, the family-owned business sells to 140 countries around the world.

FACING PAGE—
Built in 1869, Chicago's Old Water Tower housed a 130-foot-tall pipe, which served to equalize the pressure of the water provided by a nearby pumping station. In 1871, the Great Chicago Fire raged through the city, killing 300 and leaving 90,000 people homeless. The limestone tower was one of the only landmarks to survive.

23

Even in the early 1900s, leaders recognized the need to protect Chicago's unique surroundings. By 1909, the city had commissioned Daniel Burnham to create a development strategy. The finished plan included the preserved lakefront, expansive parks, and wooded paths that residents still enjoy today.

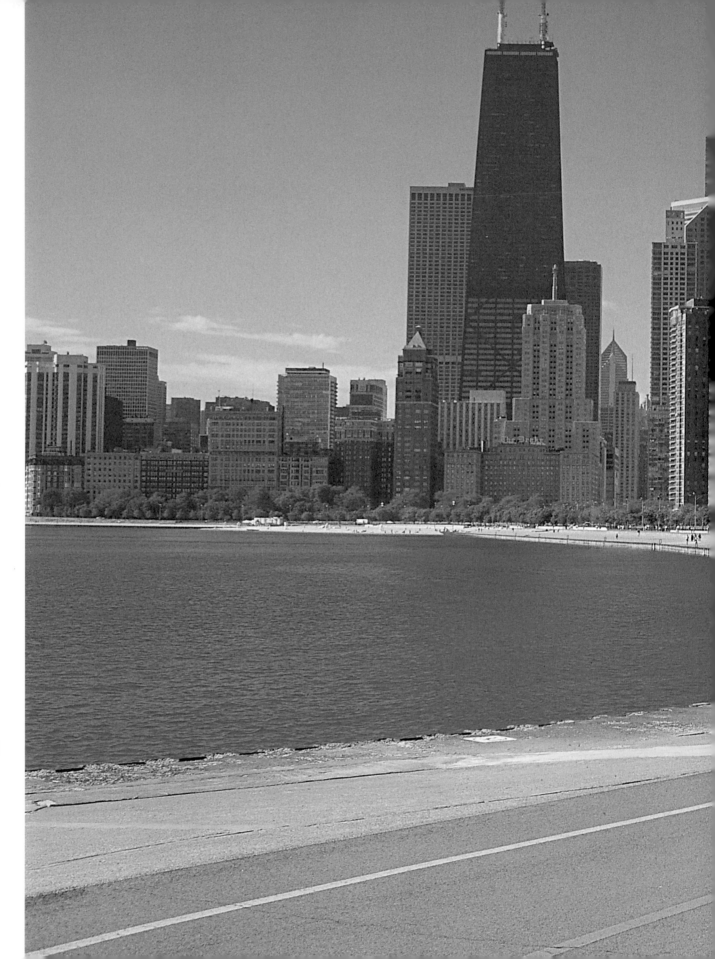

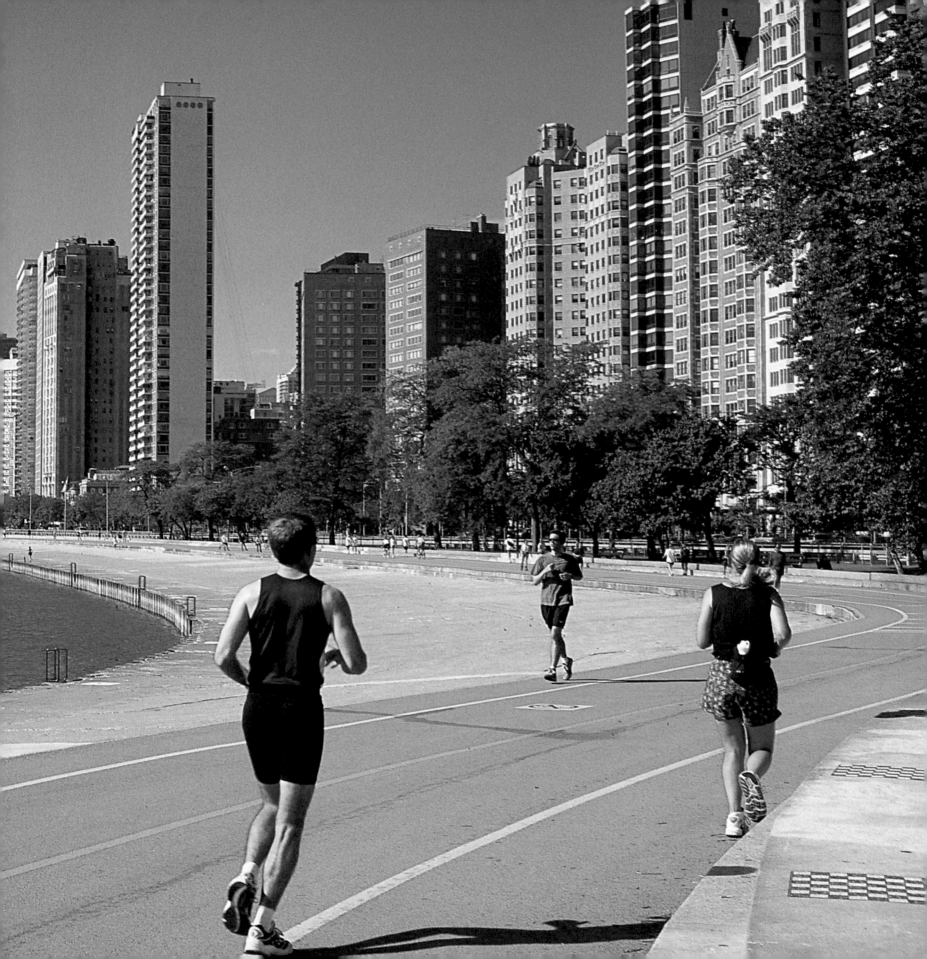

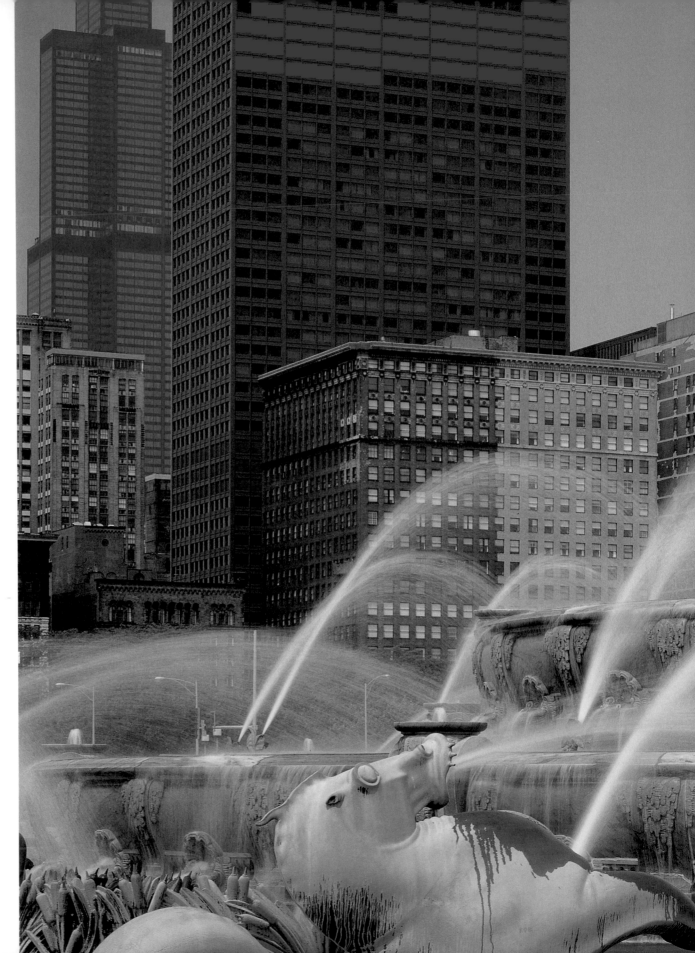

Clarence Buckingham Memorial Fountain dominates Grant Park with its 133 jets and eight bronze sea horses. Commissioned by wealthy Chicago resident Kate Buckingham in 1927, in honor of her brother Clarence, the fountain is modeled after one at the Palace de Versailles in France.

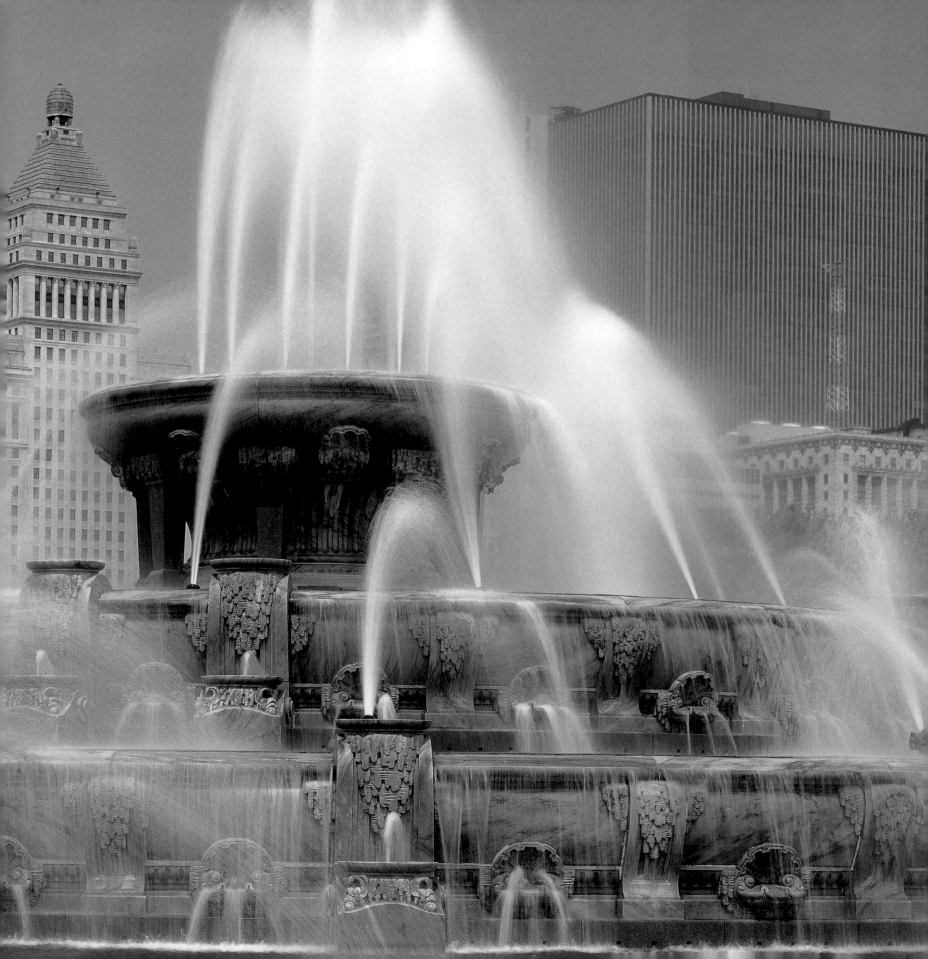

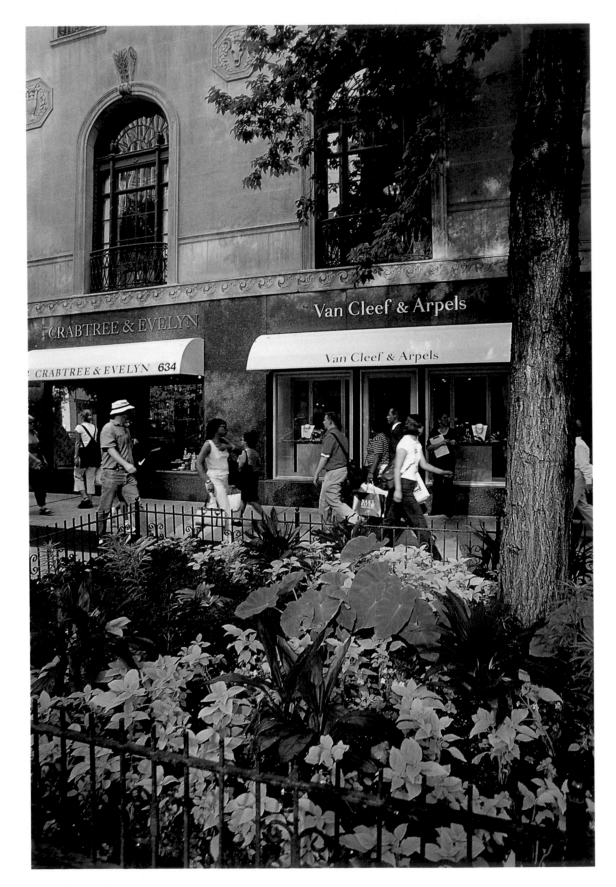

The shopping mecca of North Michigan Avenue is known as the Magnificent Mile. From Neiman Marcus and Borders Books and Music to Bloomingdale's and Saks Fifth Avenue, the neighborhood is home to some of Chicago's most exclusive stores.

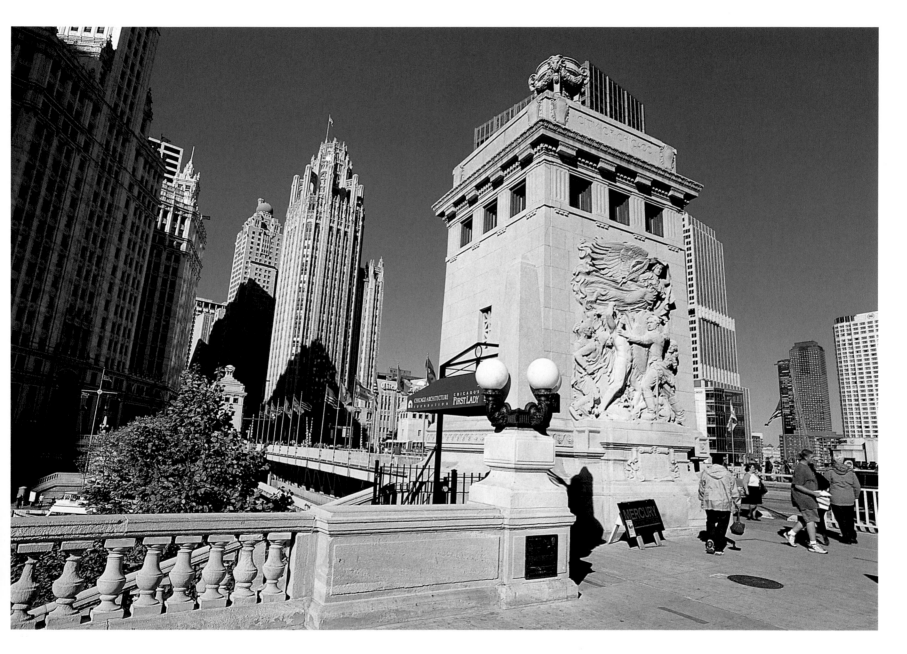

Architects Raymond Hood and John Howell created Tribune Tower after winning a *Chicago Daily Tribune*-sponsored contest to create the most eye-catching building in the world. Completed in 1925, the tower includes stones from landmarks such as the Taj Mahal, the Alamo, Westminster Abbey, and the Arc de Triomphe.

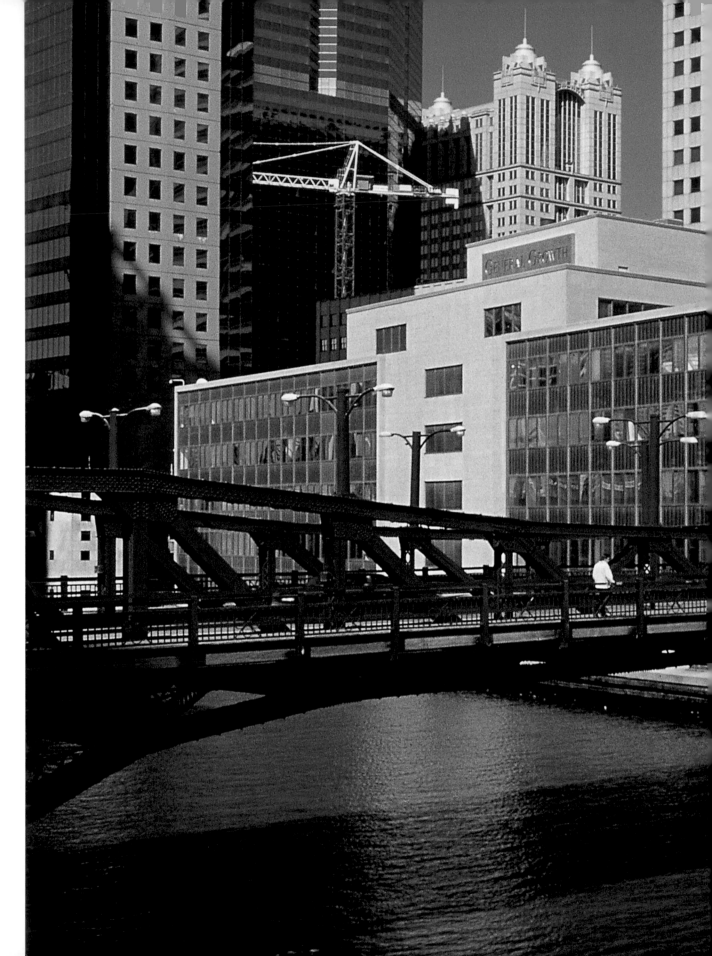

Tour boats carry visitors along the Lake Michigan shore and the Chicago River, below the city's moving bridges, or drawbridges, for a unique perspective on the architectural highlights above. Popular coffee shops and eateries line these downtown riverbanks.

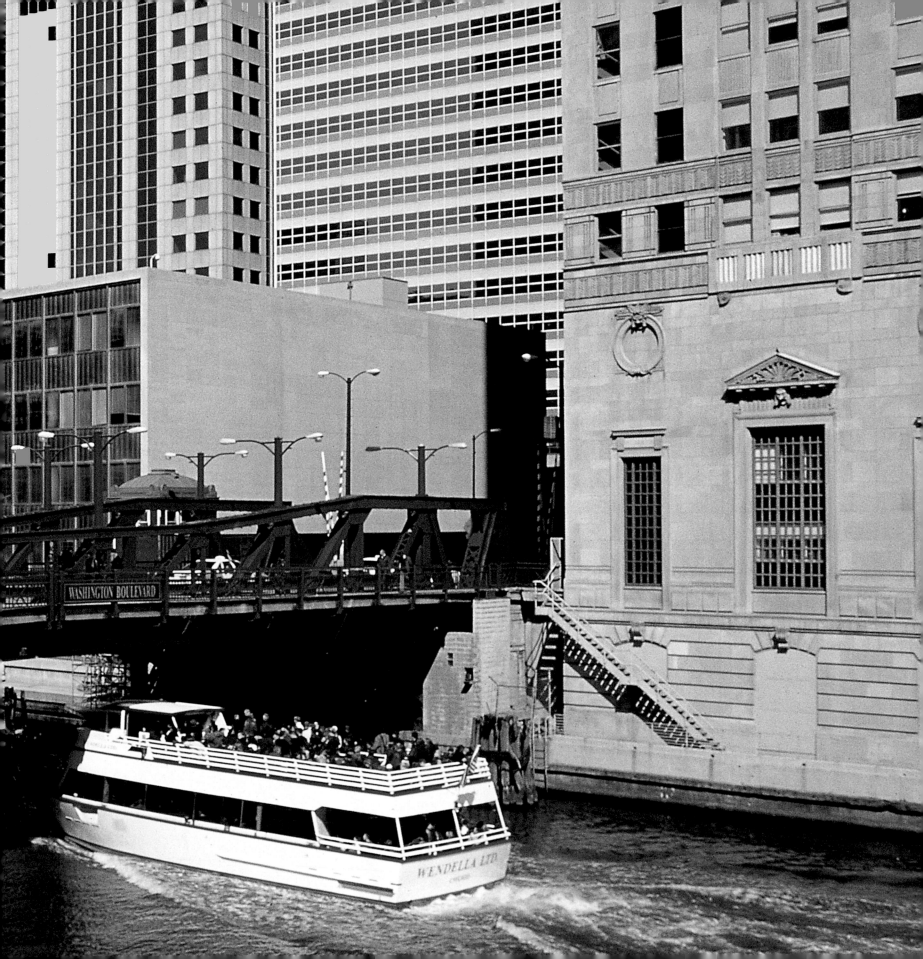

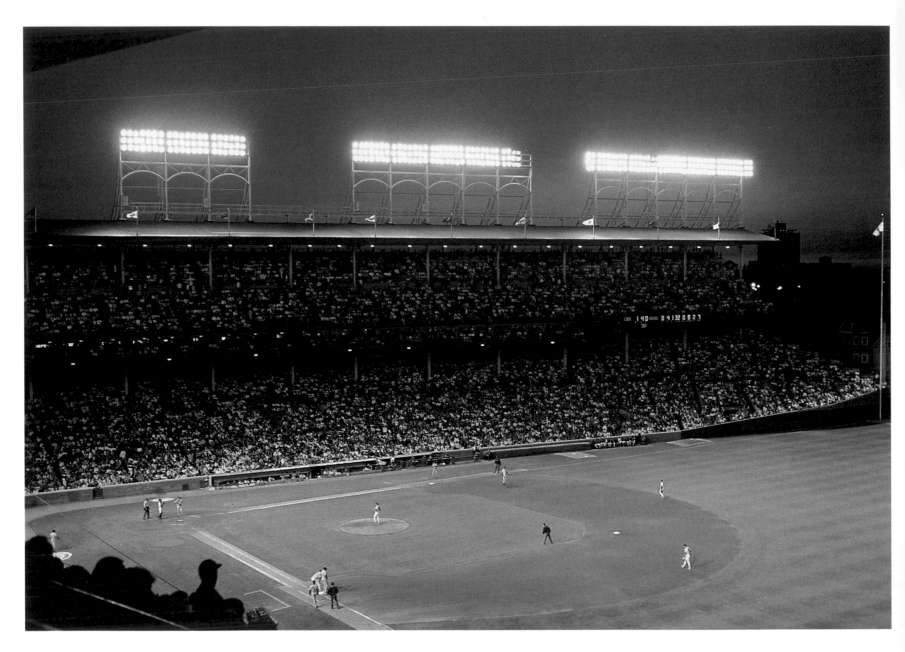

Since 1914, baseball's greatest players have tested their skills at Wrigley Field, home of the Chicago Cubs. Here, Babe Ruth hit home runs into the stands, Pete Rose achieved his 4,191st career hit, and Ernie Banks circled the bases after his 500th home run.

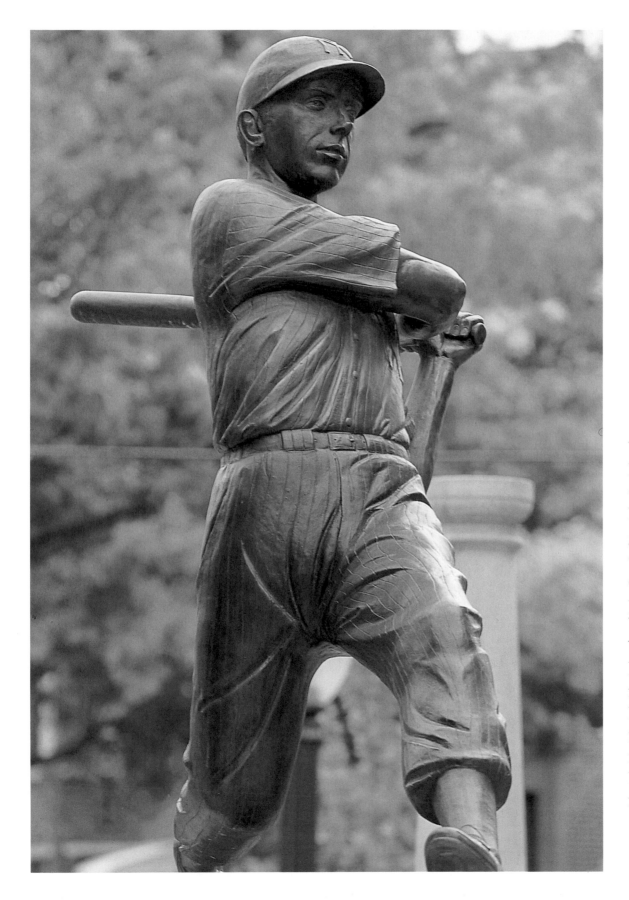

This statue of Joe Dimaggio stands in Chicago's Little Italy. Born to Italian immigrant parents in California, Dimaggio quit high school to play professional baseball. After joining the Yankees in 1936, he led the team to win nine World Series. Many people also remember Dimaggio for his marriage to Marilyn Monroe in 1954.

A giant family playground on the shores of Lake Michigan, Navy Pier consists of more than 50 acres of waterfront promenades, amusement park rides, restaurants, and performance venues. The famous Navy Pier Ferris wheel commemorates the first Ferris wheel in the world, built in 1893 for the World's Columbian Exposition in Chicago.

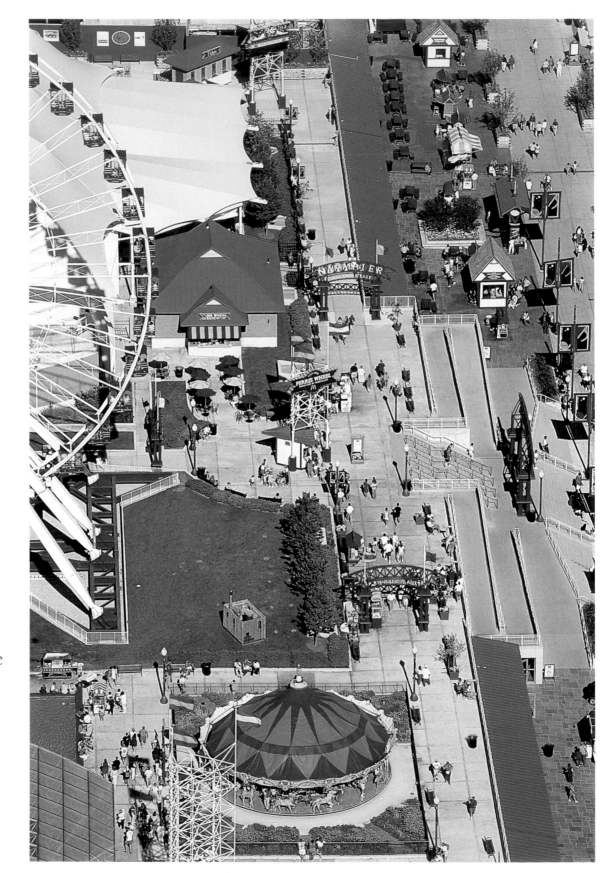

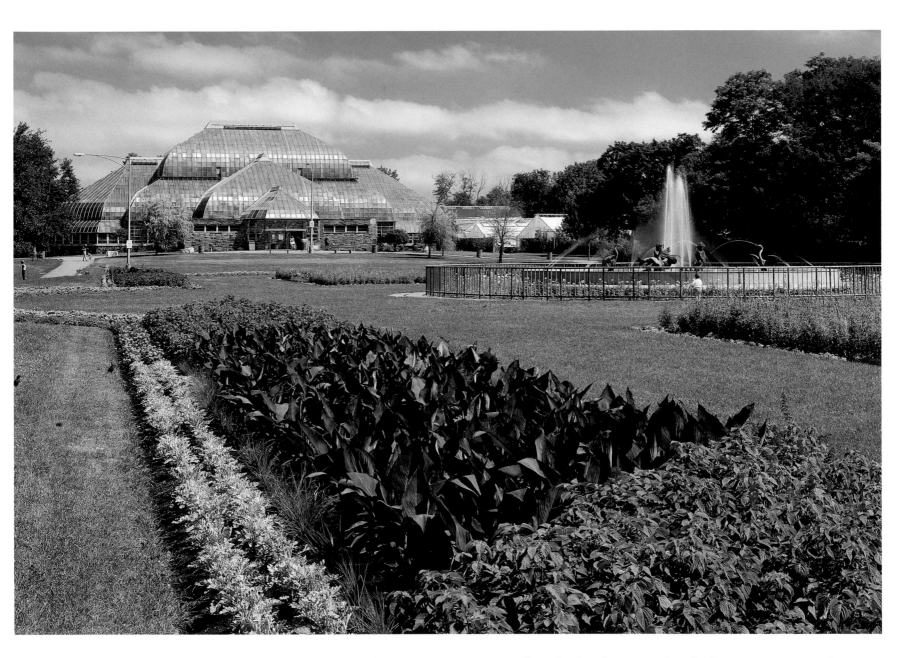

With 20,000 varieties of orchids, thousands of plants mentioned in Shakespeare's writing, a 50-foot rubber tree more than a century old, and vivid, lush seasonal displays, Lincoln Park Conservatory is a green thumb's paradise. The conservatory opened its doors in 1893 and attracts about a million visitors each year.

At the Field Museum, visitors gain an up-close look at the world of natural history, from the largest *Tyrannosaurus rex* skeleton ever found—now named Sue—to the remains of the legendary people-eating lions of Tsavo. The museum explores human history as well, through such exhibits as a full-size Pawnee earth lodge and displays of ancient Egyptian art.

FACING PAGE–
The Art Institute of Chicago is known around the world for its collection of French Impressionist paintings, including 33 works by Monet. Other exhibits feature 35,000 Asian artifacts, an overview of photography from 1839 to the present, and more than 66,000 fabric swatches, some made as early as 300 B.C.

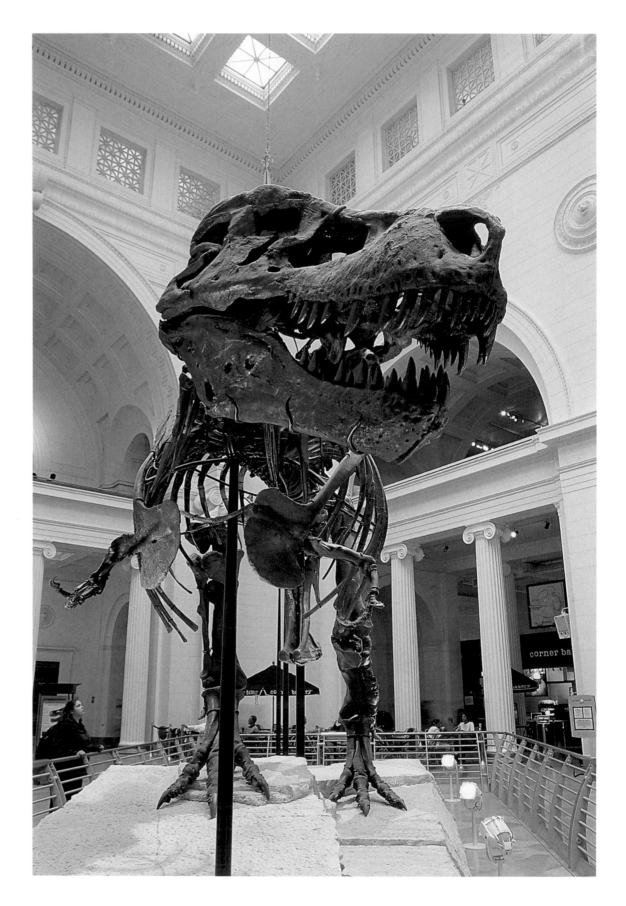

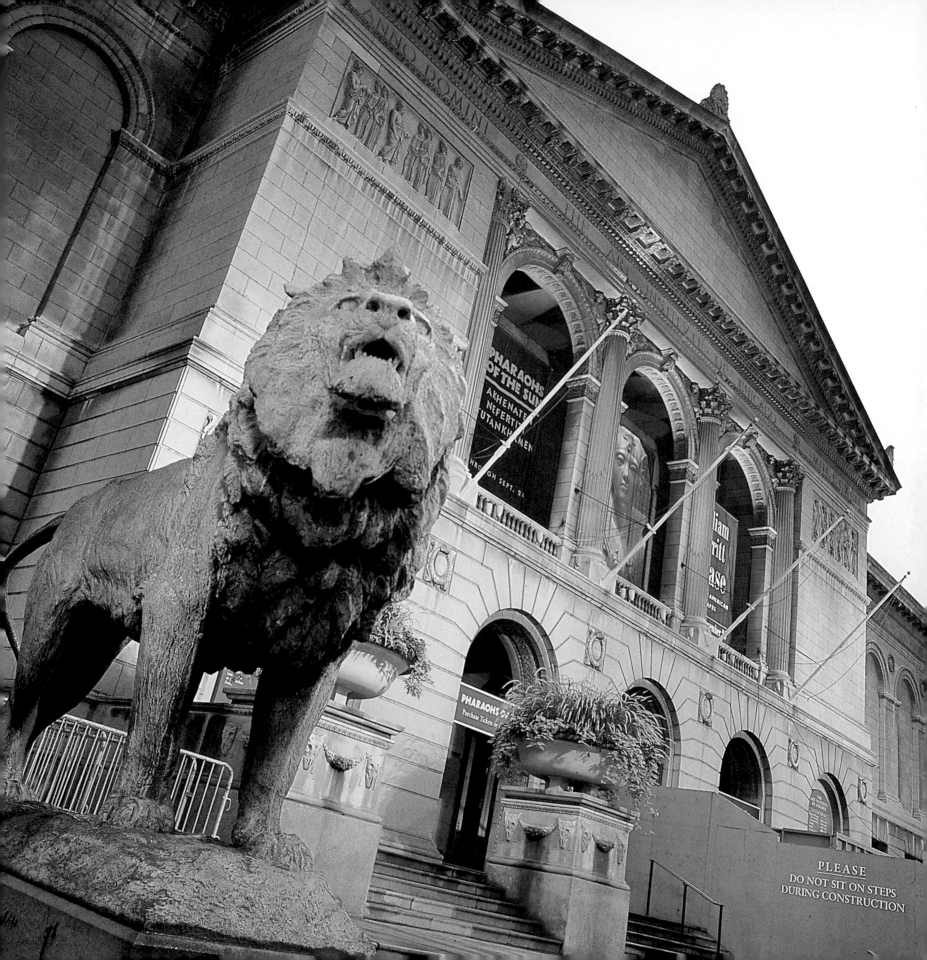

PLEASE
DO NOT SIT ON STEPS
DURING CONSTRUCTION

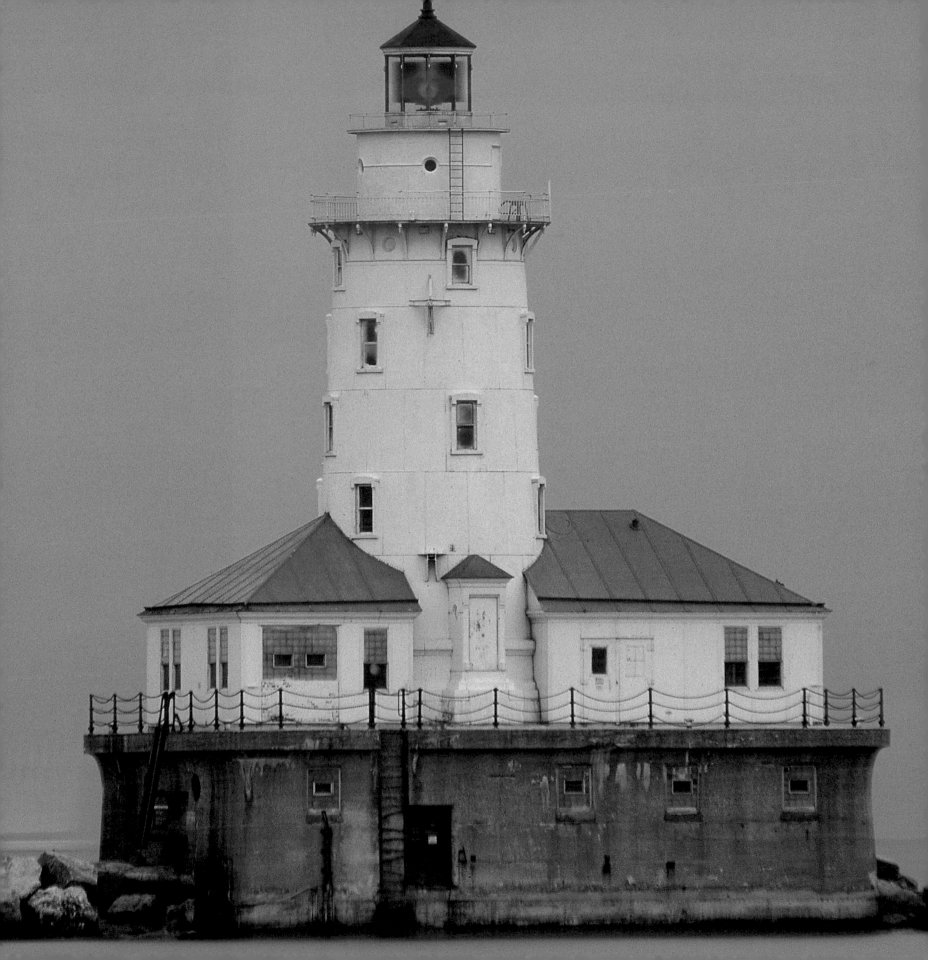

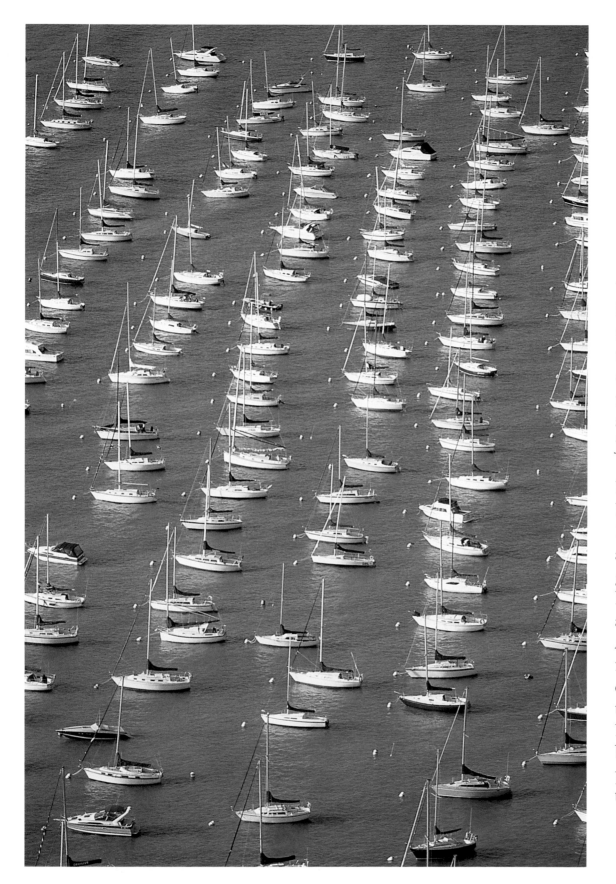

The Chicago Yacht Club, founded in 1869, is one of the foremost yacht clubs in the world. The clubhouse on Monroe Harbor offers members access to the attractions of downtown, just a few steps away.

FACING PAGE—
Between 1833 and the early 1900s, Chicago's importance as a shipping destination grew exponentially, and harbor improvements were almost constantly underway. After the breakwater was refurbished in 1917, a beacon built in 1893 to light the mouth of the Chicago River was moved to the breakwater's southernmost point to guide vessels toward the city.

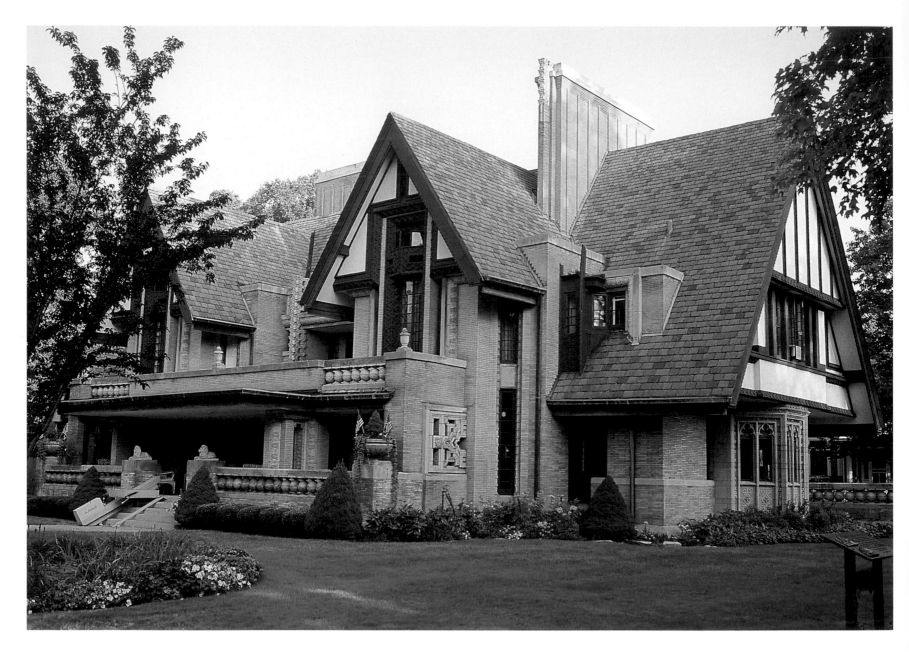

The Frank Lloyd Wright Preservation Trust maintains the architect's home and studio as they were in 1909, before Wright moved out of the neighborhood. Wright took an organic approach to architecture, adjusting his designs to the natural landscape. He won fame for his long, spacious Prairie houses.

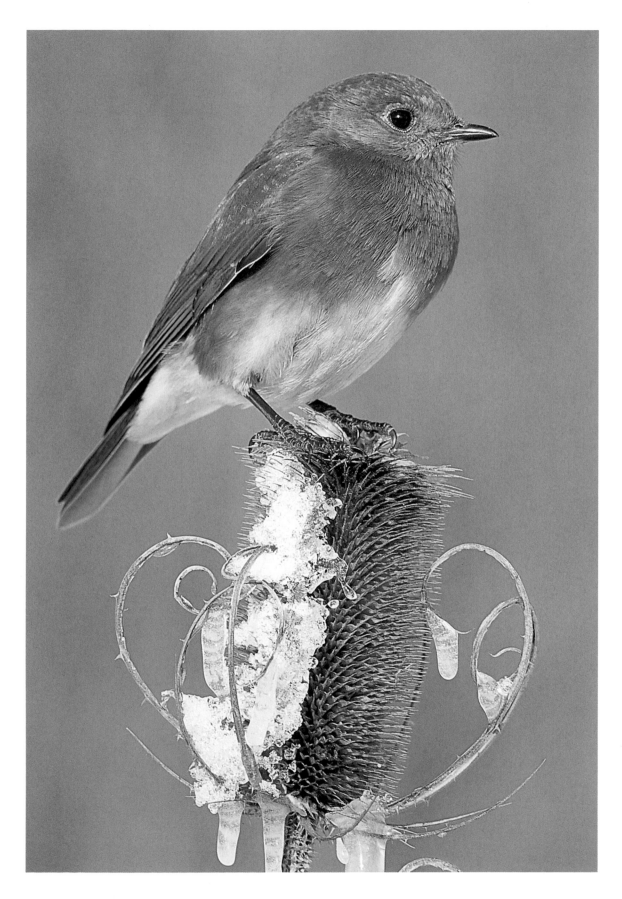

An eastern bluebird keeps a sharp lookout for insects in early spring. The bluebird often lives on the edges of agricultural areas or marshlands, where nearby trees provide nesting places and safe refuges for its young.

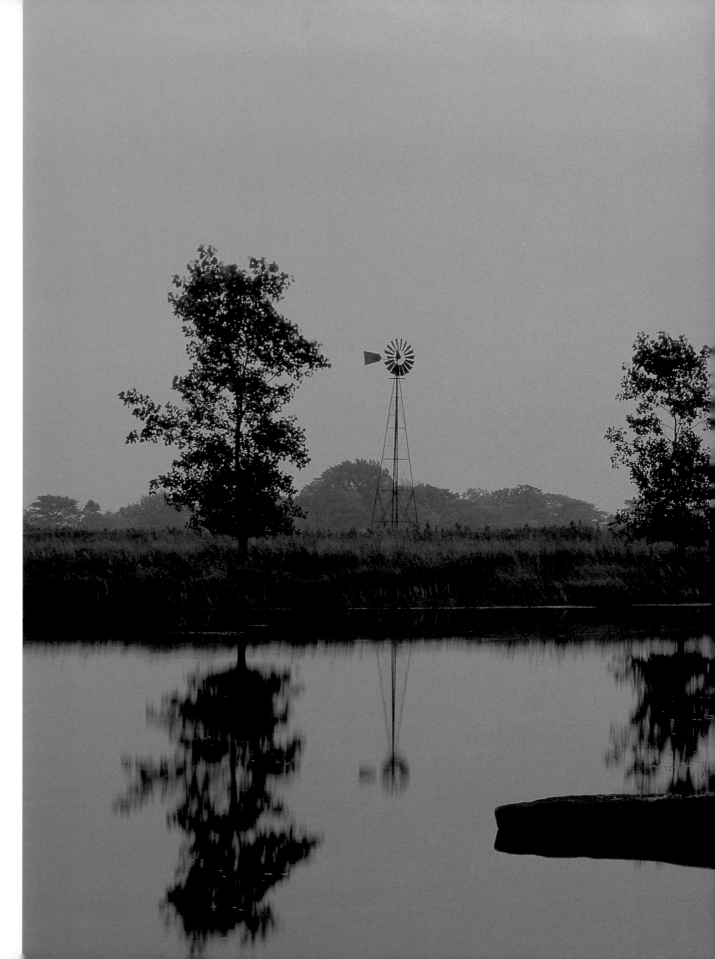

Like most of Illinois, the land that is now Goose Lake Prairie State Natural Area was once buried deep under ice. This 2,537-acre preserve now protects remnants of the natural prairie landscape that were left behind when the glaciers retreated. Tall switch grass and prairie cordgrass offer shelter to deer, coyotes, rabbits, barred owls, and hawks.

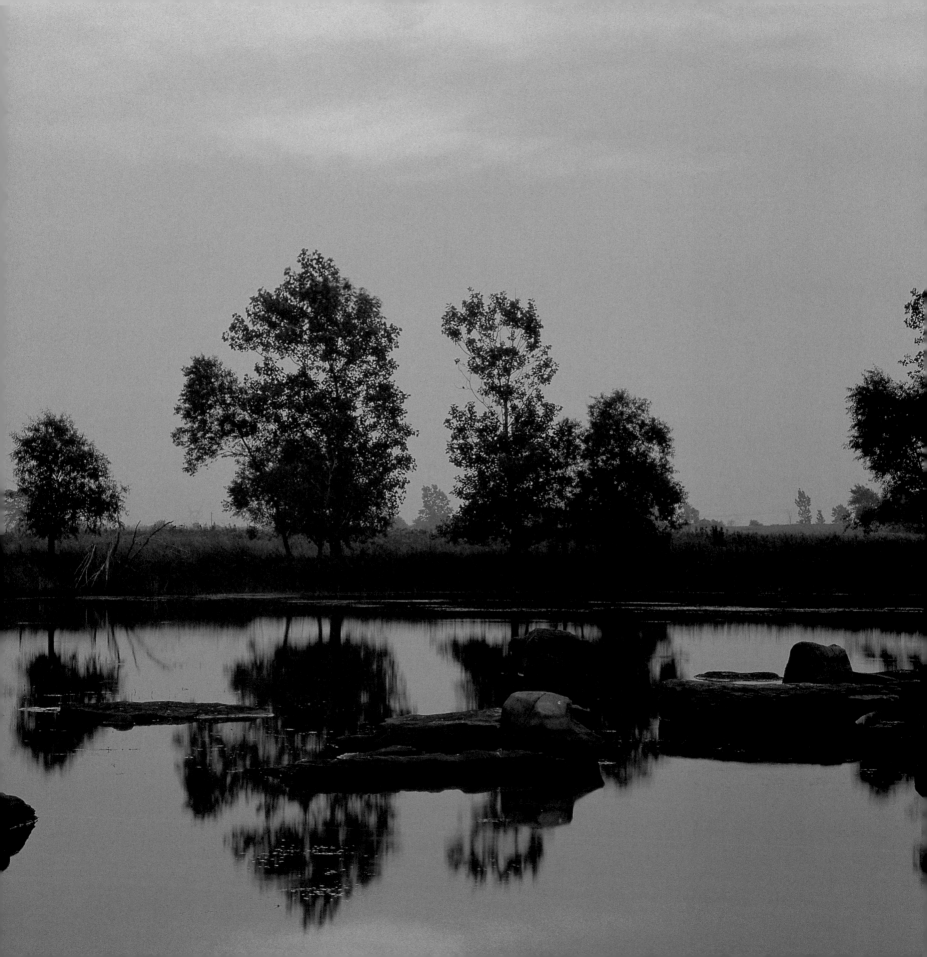

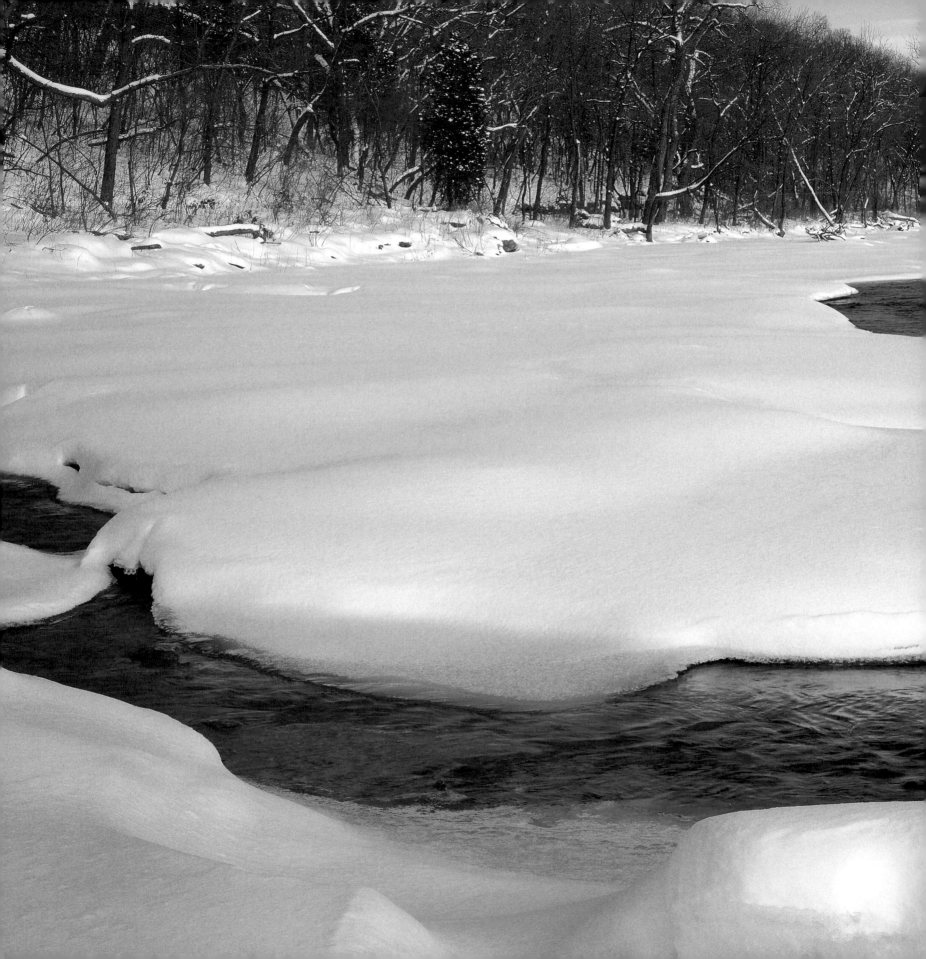

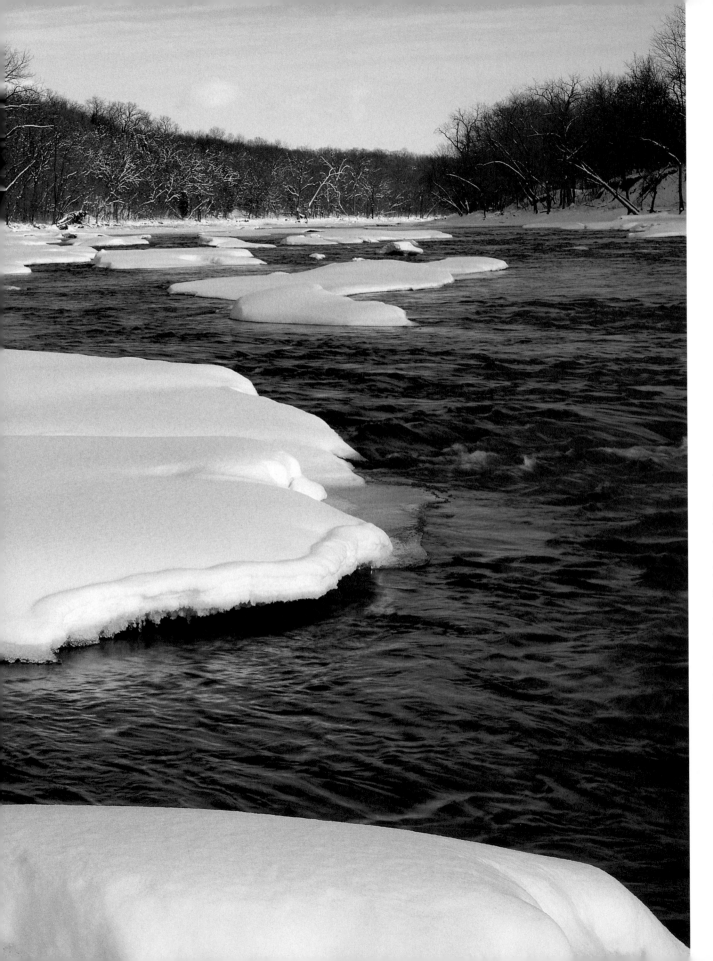

Ice clings to the banks of the Vermilion River in LaSalle County. This region was named for French explorer Robert de la Salle who founded the first two European fur-trading posts in Illinois in the 1680s. From here, he sailed down the Mississippi River to the Gulf of Mexico, naming the newly charted land Louisiana, in honor of the King of France.

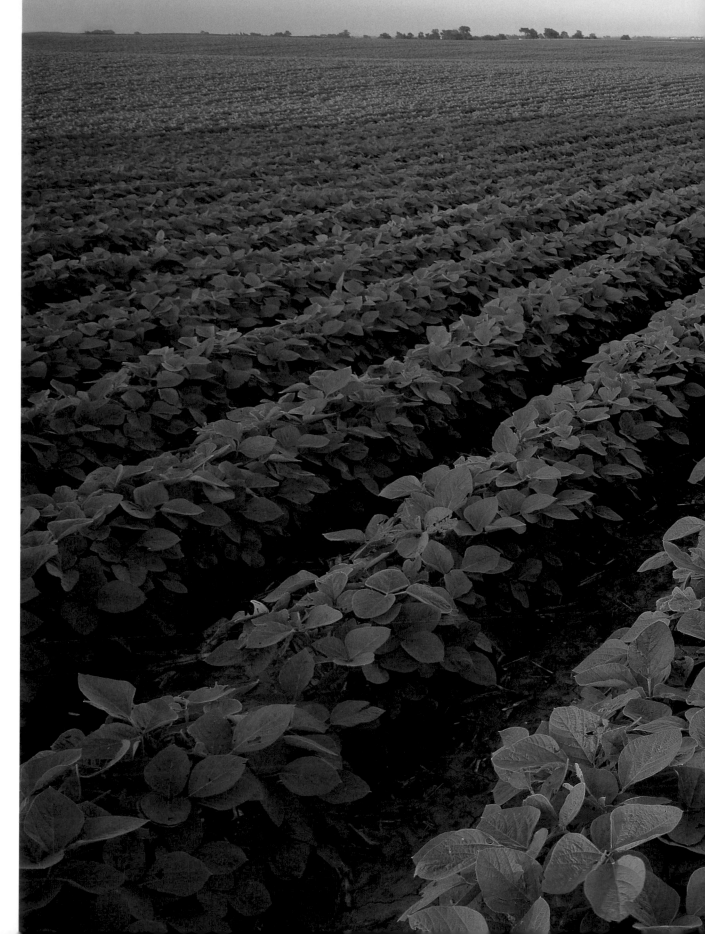

Variations in climate
and soil allow Illinois
farmers to produce
a wide range of crops,
from these soybeans—
one of the most
profitable—to apples,
herbs, mushrooms,
and strawberries.

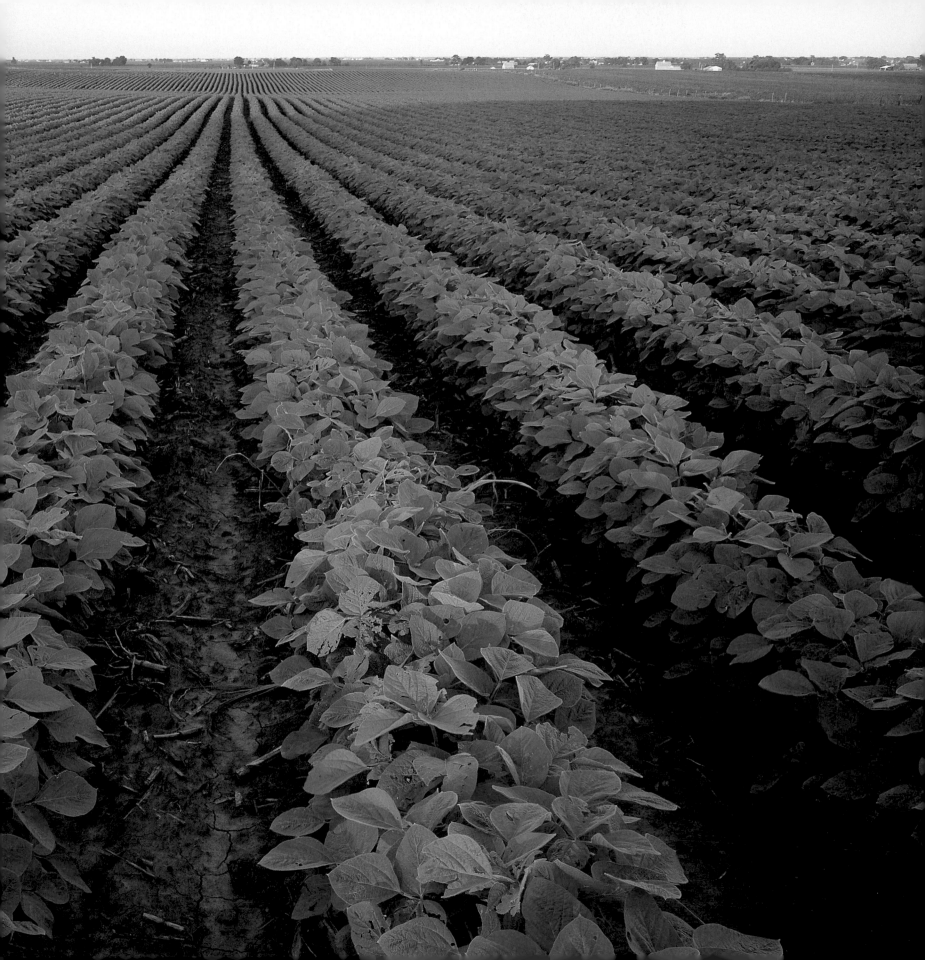

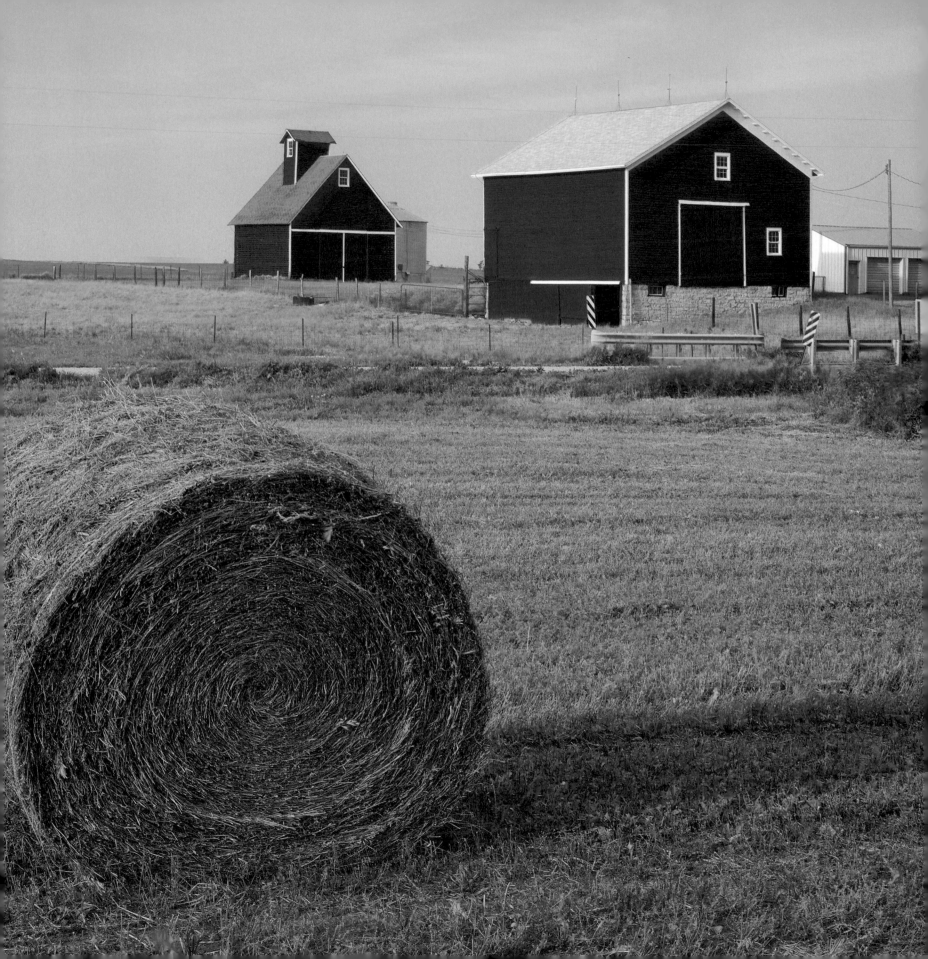

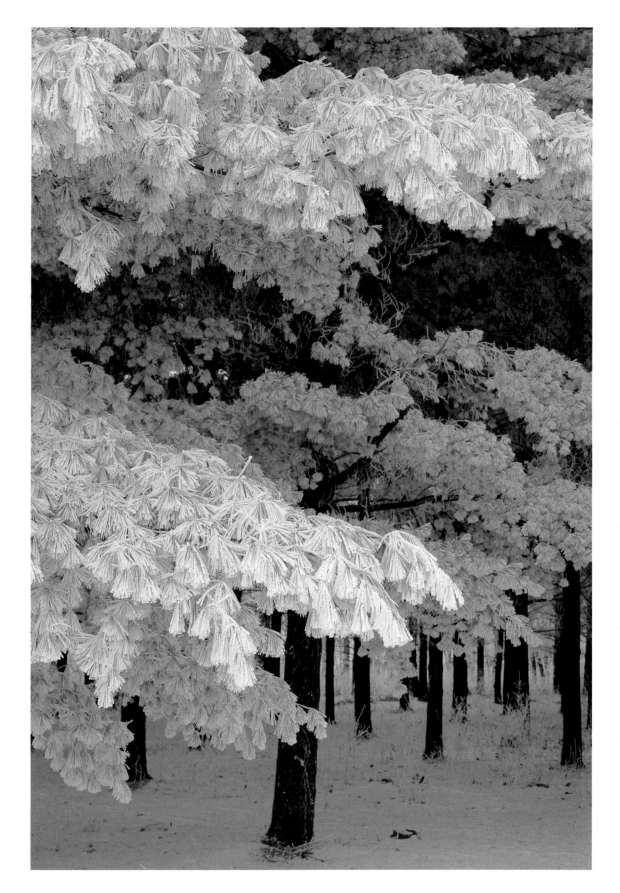

When French explorers arrived in the Midwest in the 1600s, they met the Illinois people, or the Illiniwek, and named the region for them. *Illinois* is believed to mean "tribe of superior men."

FACING PAGE—
Almost 80 percent of Illinois is farmland. More than 76,000 farms, many still family-owned, employ thousands of workers. Taking advantage of the many agricultural products available, 14,000 food companies are based within the state.

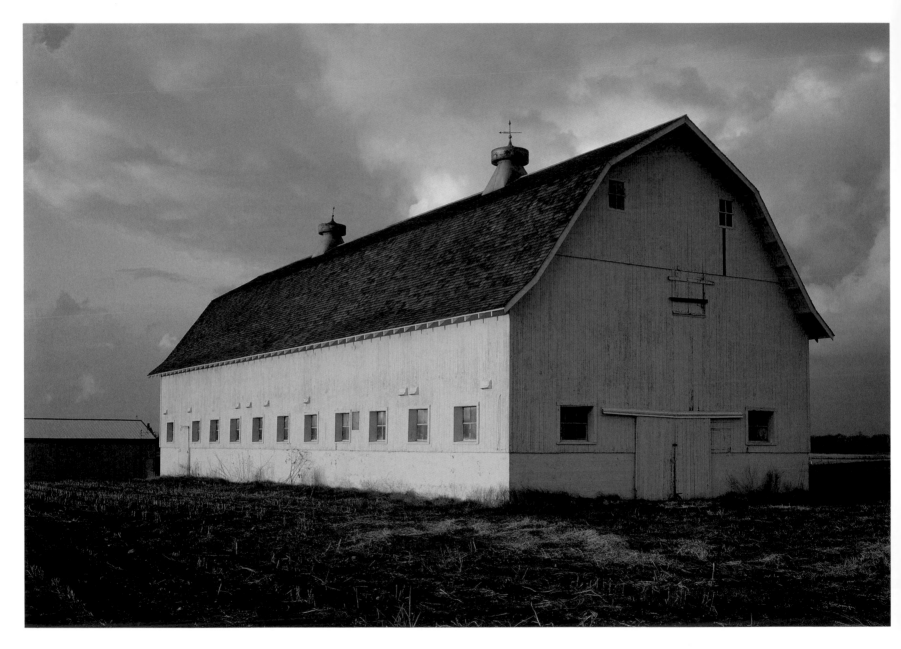

An extensive transportation network links rural Illinois with Chicago. Both people and agricultural products travel on 2,000 miles of interstate highway, 34,500 miles of state highway, and more than 1,000 miles of navigable water. There are also 656 airports scattered throughout the state.

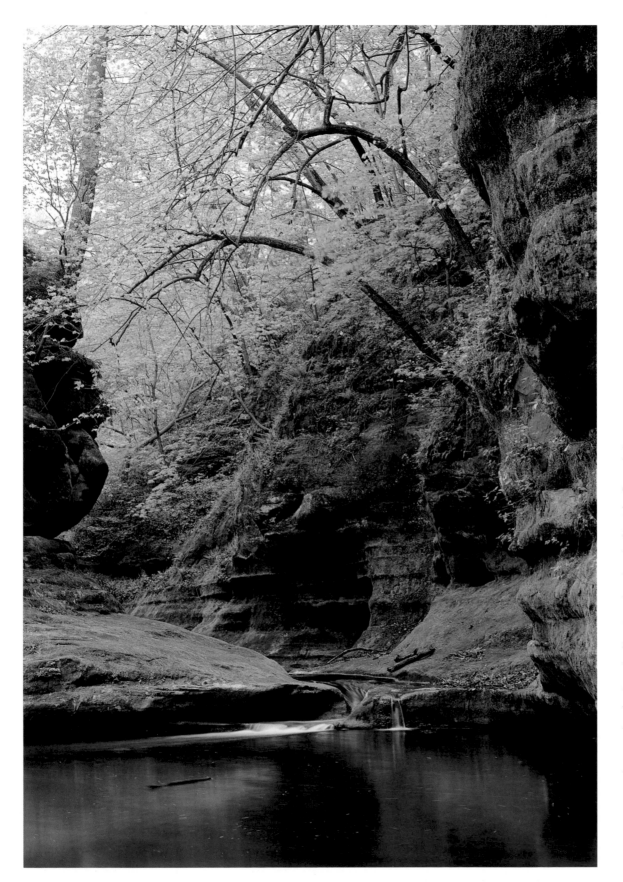

Starved Rock State Park is named for an event that happened more than 200 years ago. After a chief of the Ottawa native tribe was killed by the Illiniwek, a band of warriors arrived to seek revenge. They trapped the Illiniwek on a butte, surrounding the site until the people starved. That 125-foot outcrop is now part of the 2,816-acre preserve.

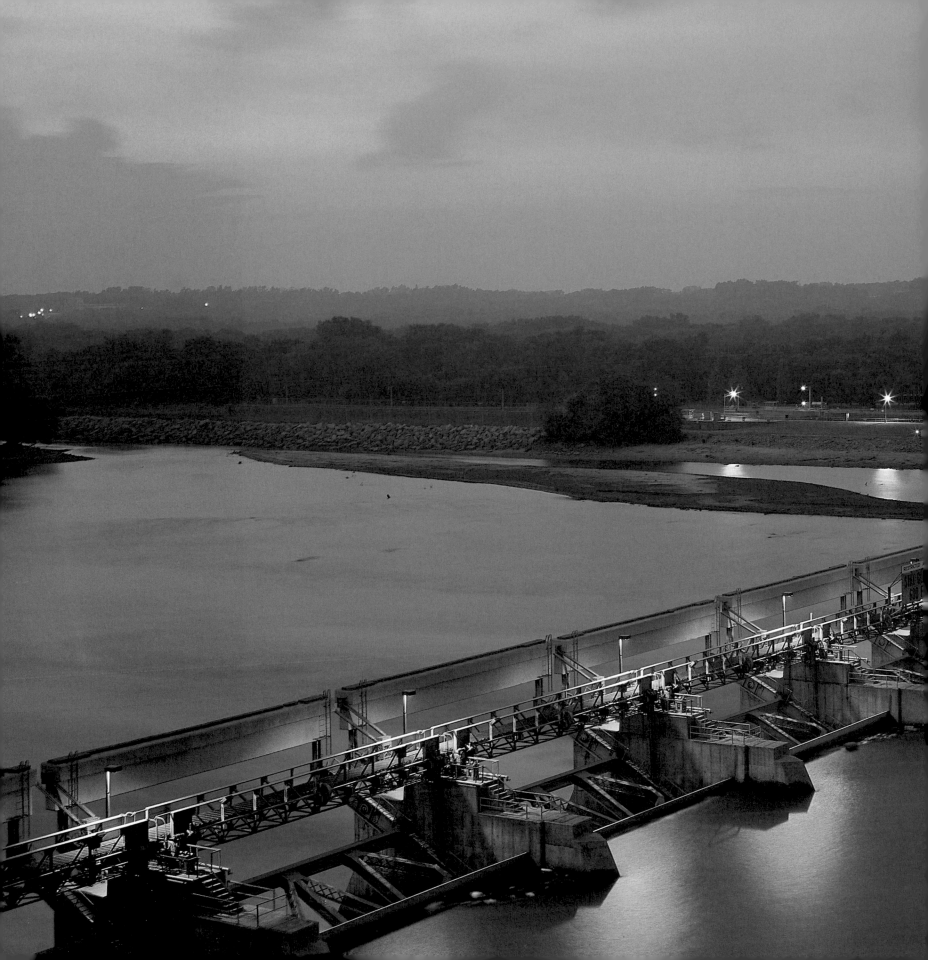

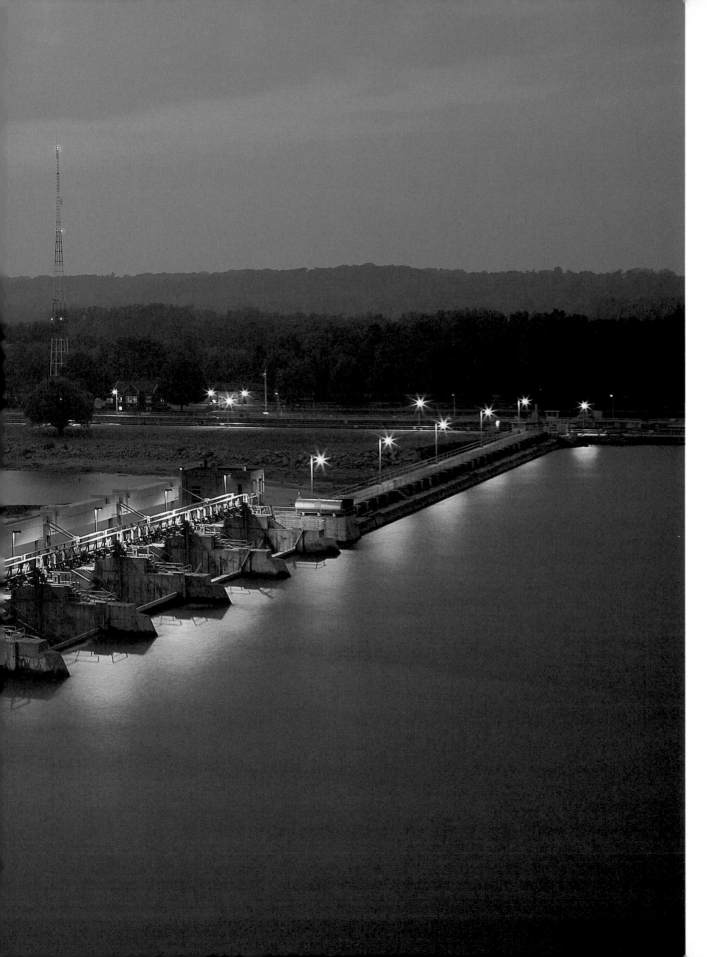

From the Illinois Waterway Visitor Center, curious travelers get a detailed look at the operations of Starved Rock Lock and Dam. One of eight locks on the Illinois River, the Starved Rock structure helps to ensure nine feet of water flows through the channel at all times—enough to allow commercial shipping vessels to safely pass.

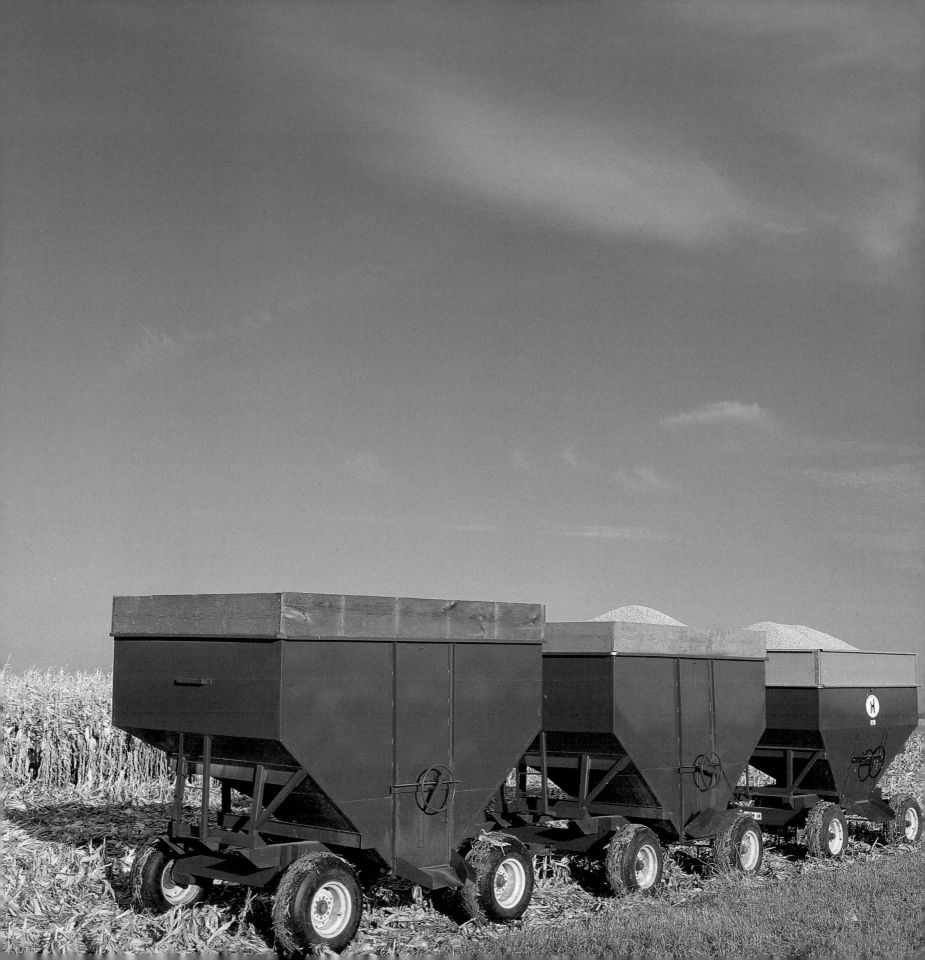

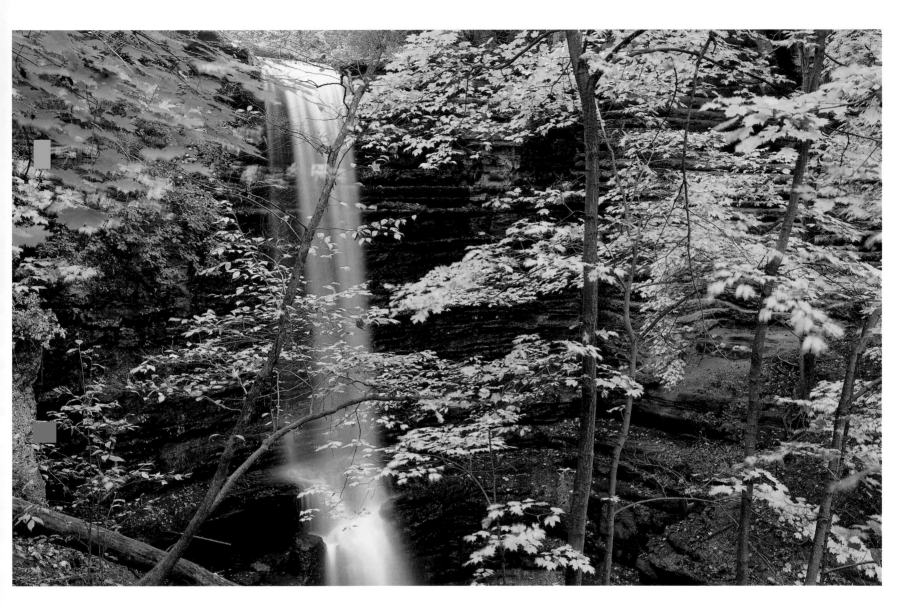

Five miles of hiking trails within Matthiessen State Park guide visitors to some of the region's canyons, bluffs, and waterfalls. The rock walls throughout the park are composed of 425-million-year-old sandstone, exposed by centuries of erosion.

More than 11 million acres are planted with corn in Illinois—the state is second only to Iowa in production of the crop. Much of the harvest—about 270 million bushels—is used to produce 678 million gallons of ethanol each year.

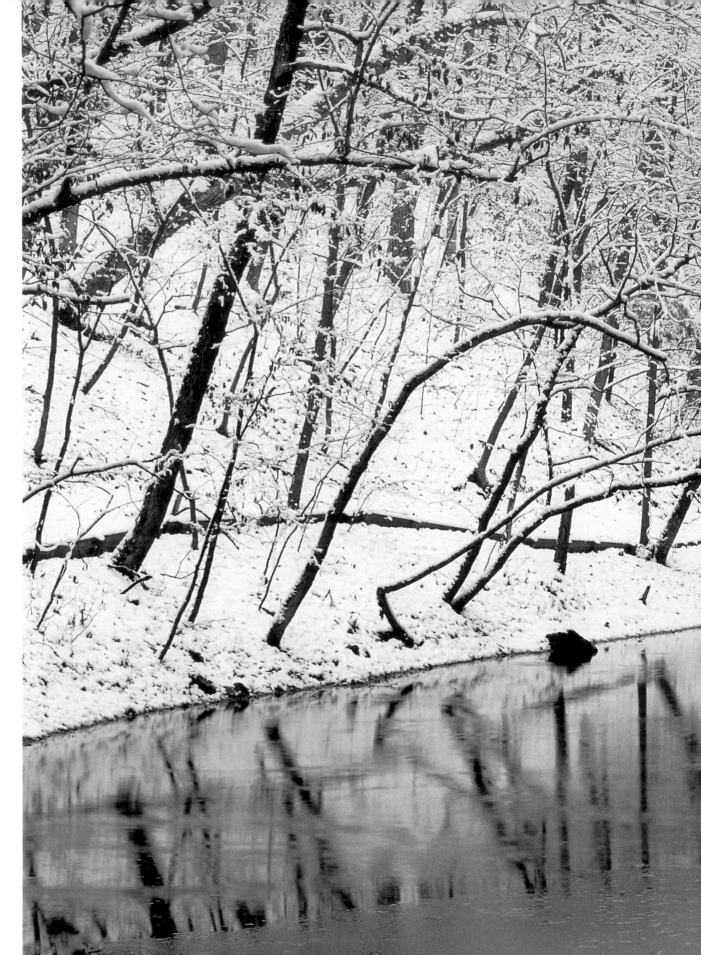

Local industry magnate Frederick William Matthiessen bought 176 acres in the late 1800s and used it as a private park, hiring workers to create walking trails through the woods. The land was donated to the state upon Matthiessen's death, and an expanded 1,938-acre public park named in his honor opened in 1943.

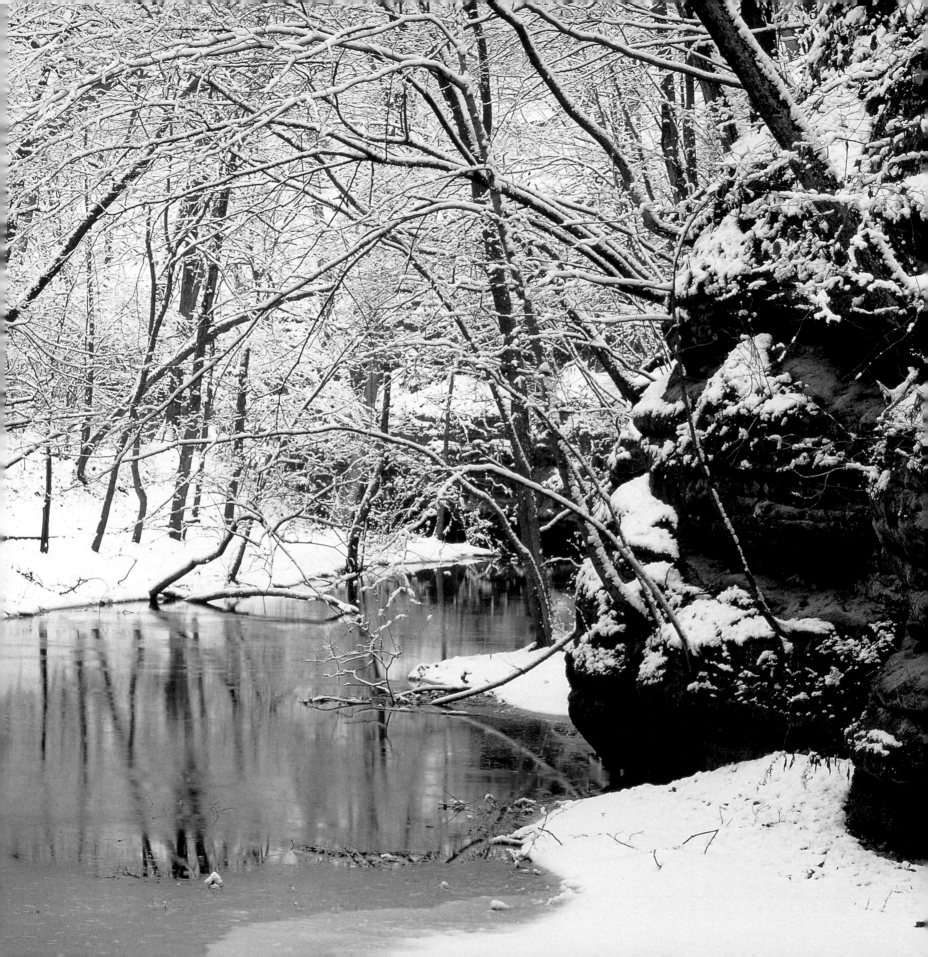

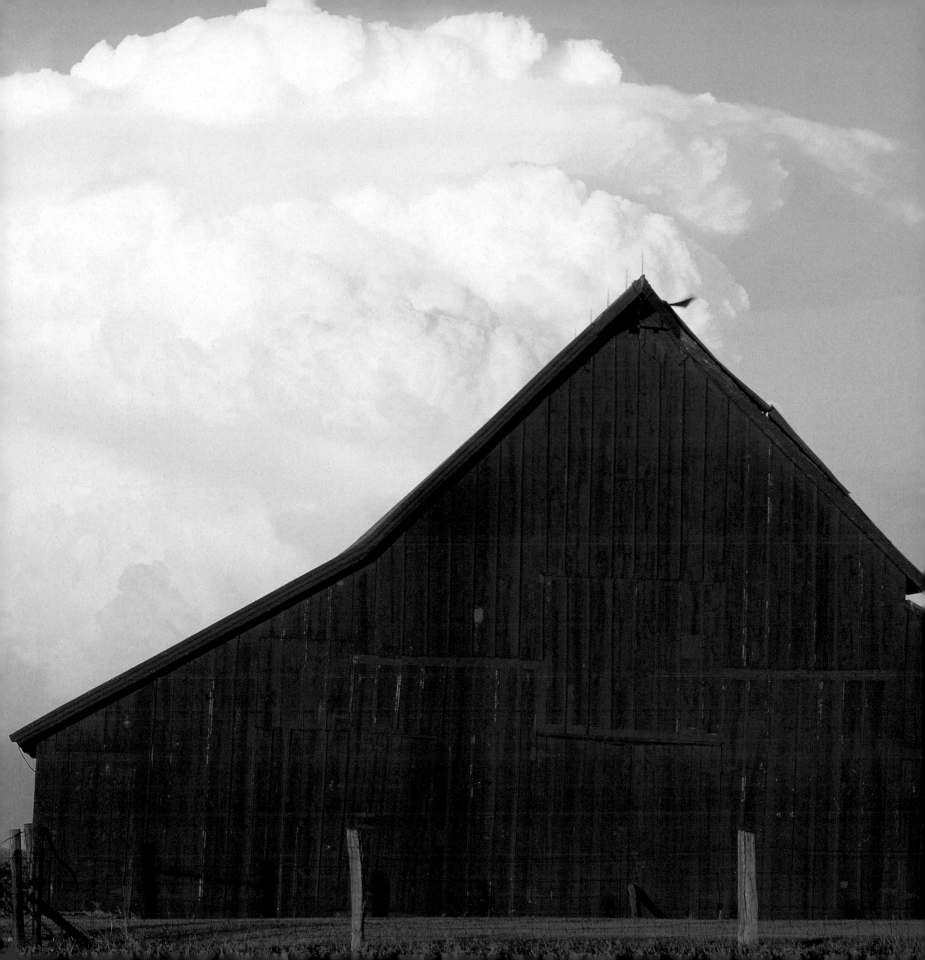

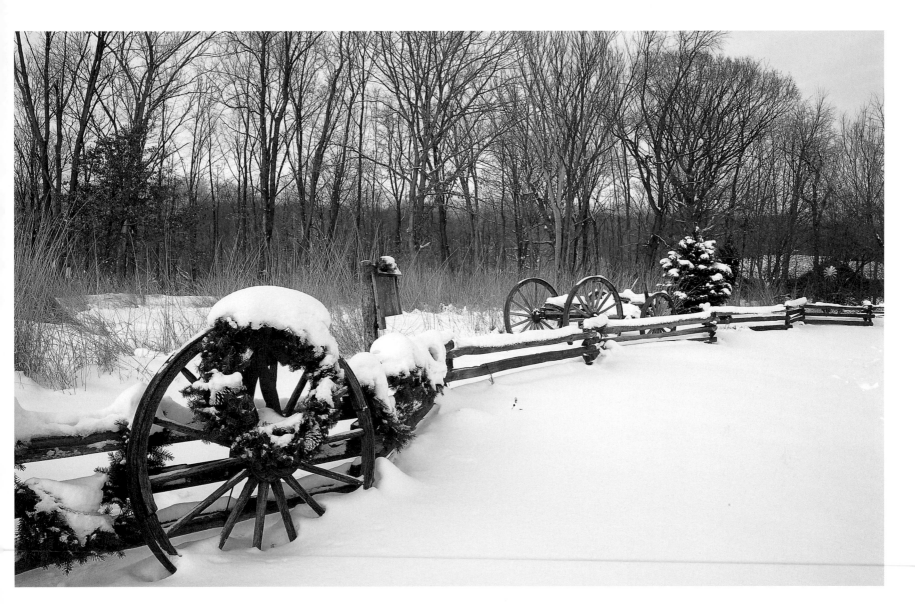

Just over 100 miles southwest of Chicago, Bureau County is a land
of small towns and picturesque family farms. Residents break the long
winter with frequent festivals and events, from holiday home tours and
tree-lighting celebrations at Christmas to winter hiking challenges.

In Illinois, about 65 percent of the population lives in Chicago and
the surrounding suburbs. Only 15 percent live in agricultural areas.

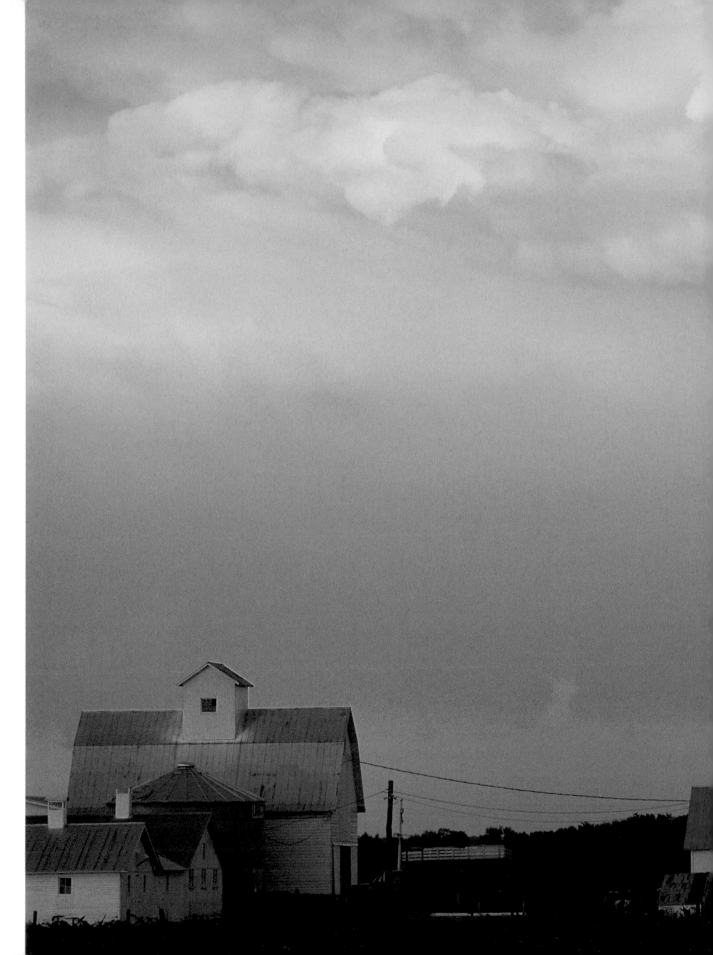

A thunderhead looms in the sky above a Bureau County farm. Sudden showers and thunderstorms are common in Illinois, as hot and cold air collide at the end of long summer days. The rainfall is essential to the state's crops, but damaging hail and high winds sometimes accompany these storms.

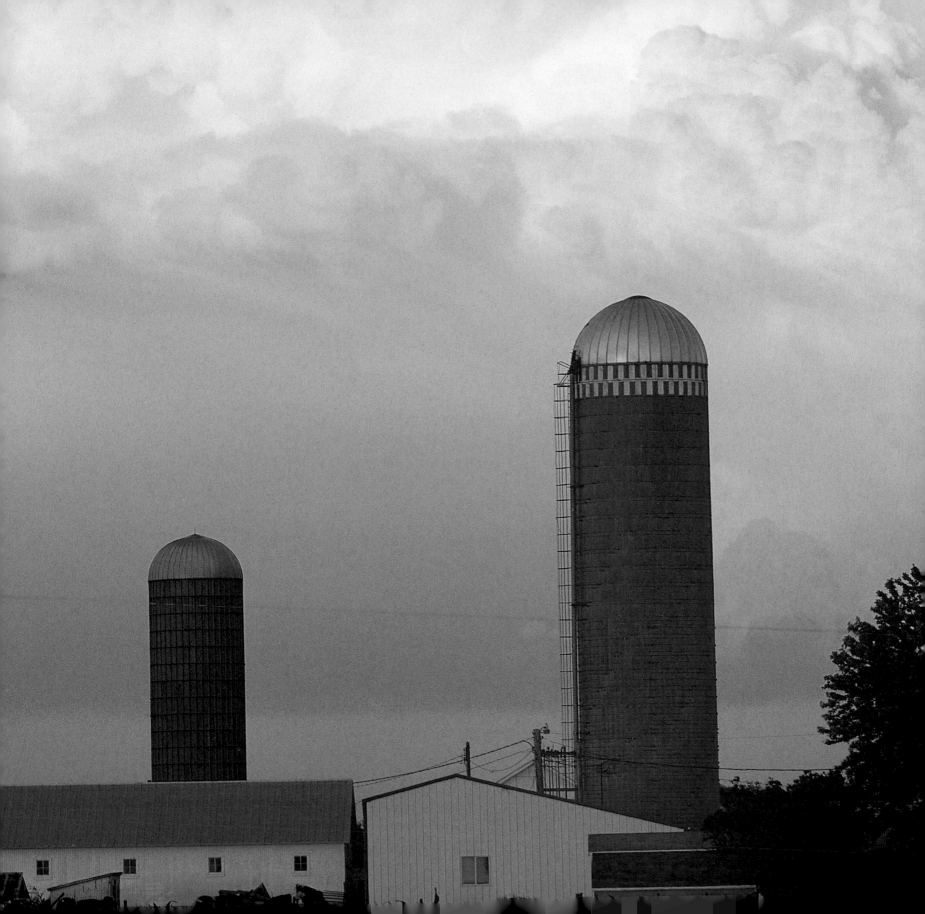

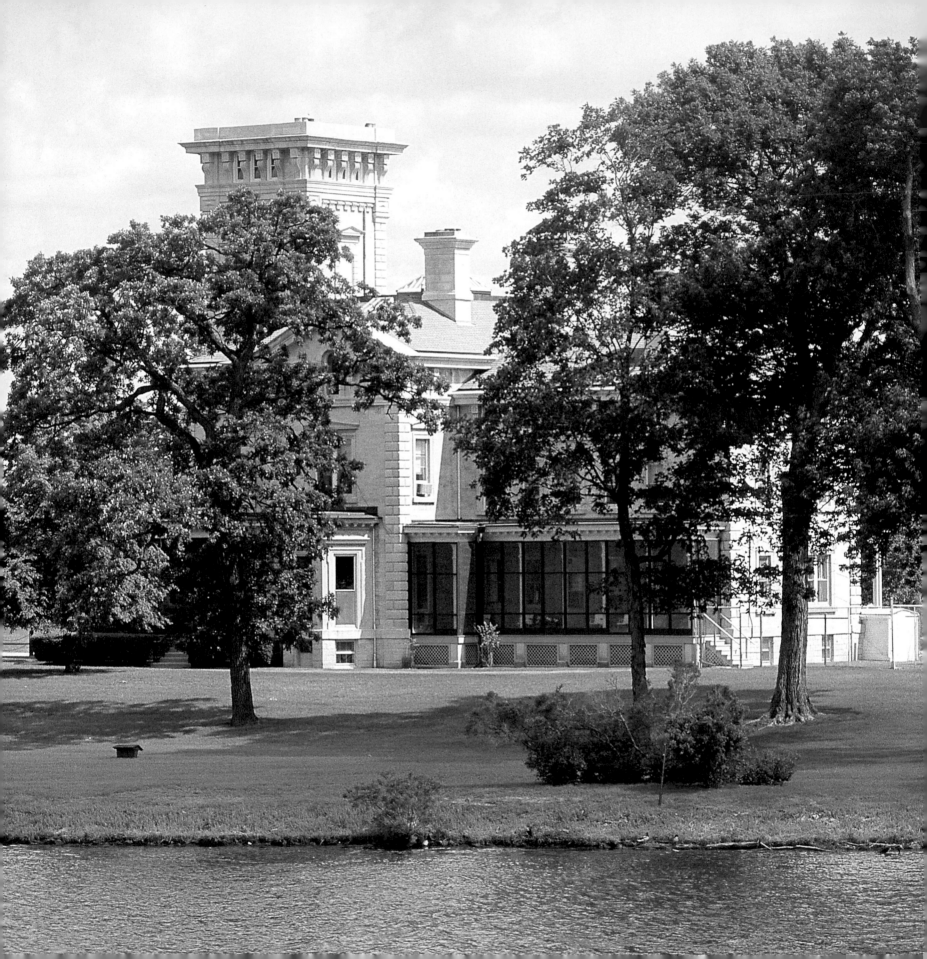

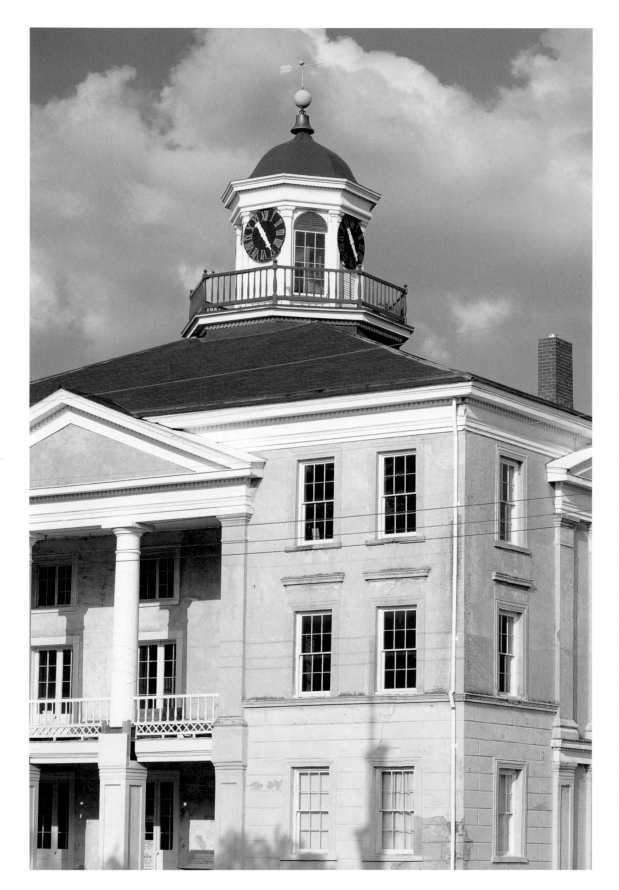

The brick and stucco Steeple Building at Bishop Hill State Historic Site was built in 1854. One of more than 20 structures built by the colonists, the three-story, 24-room structure is now a heritage museum.

FACING PAGE—
In the nineteenth century, Rock Island was a boisterous railway town, home to gamblers and outlaws, settlers and entrepreneurs. Those who were successful built grand homes along the banks of the Mississippi, some of which survive today.

Bishop Hill State Historic Park preserves the site of a Swedish colony established in 1846 by the followers of Eric Janson, a man convinced that the Swedish church was lax and corrupt. Within 15 years, the colony had attracted more than 1,000 immigrants. However, poor living conditions, dissent among the colonists, and embezzlement by trustees led to the community's dissolution in 1861.

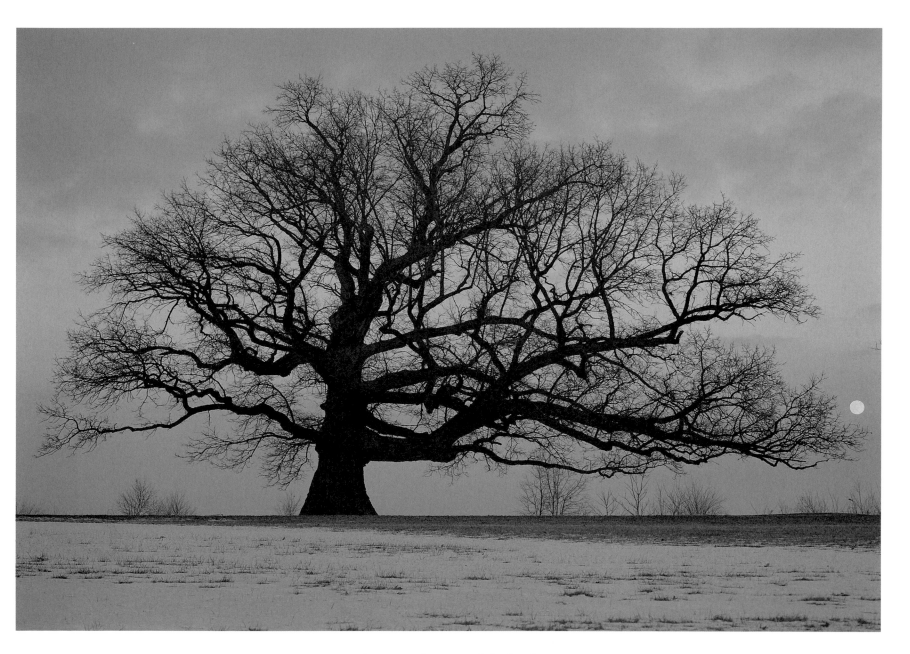

When settlers established Putnam County in 1825, it extended from the Illinois River to the border of Wisconsin. During the following decade, Bureau, Stark, and Marshall counties emerged, encompassing much of Putnam County until only 166 square miles remained. Today, this is the smallest county in the state.

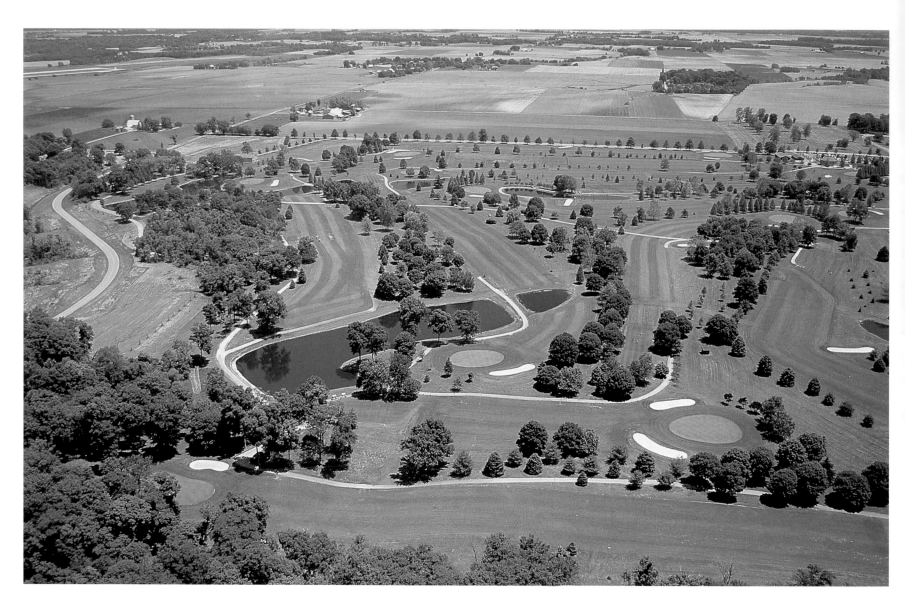

Tilled fields meet the carefully tended greens of a golf course in central Illinois. There are more than 500 professional golfers in the state working at more than 300 courses. One of the most popular events of the year is the Illinois Open, a 54-hole tournament played annually since 1950.

The Western Golf Association was born near Chicago in 1899, and now includes 500 courses across the nation. Along with annual tournaments, the association sponsors the Chick Evans Caddie Scholarship, which has provided more than 7,400 caddies with the resources to attend college.

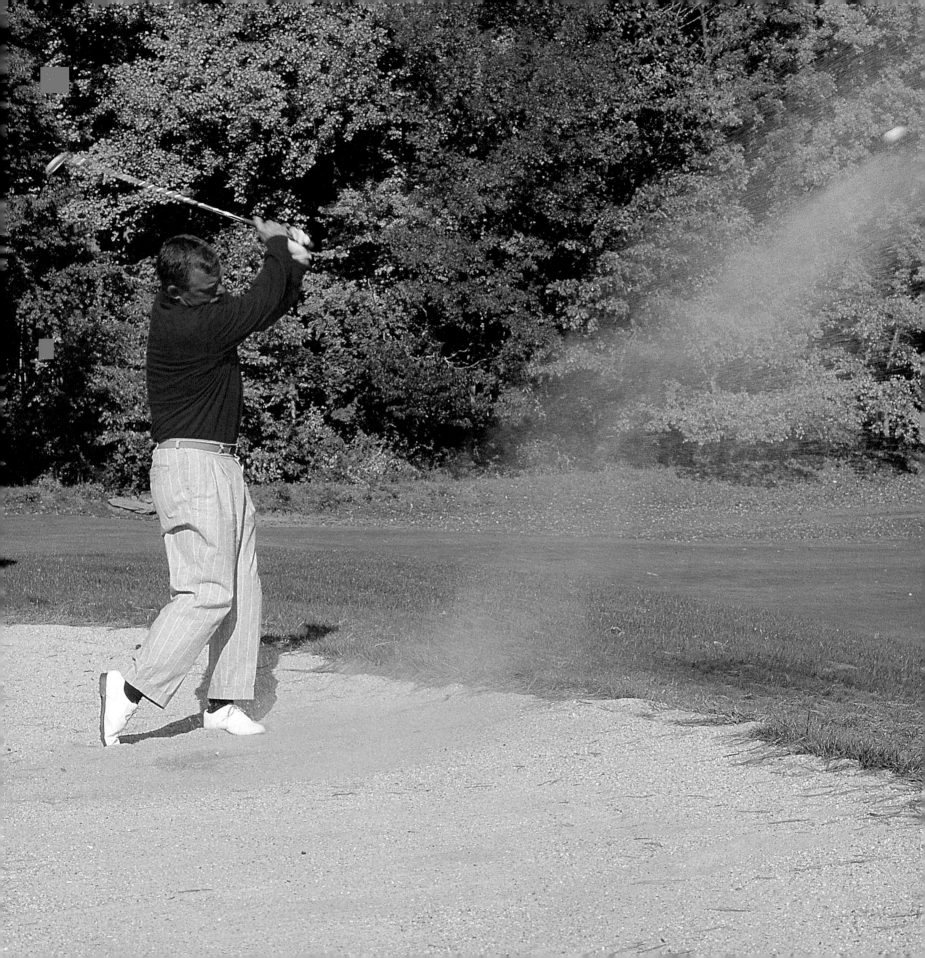

This bridge in Lake of the Woods County Park near Champaign is a 1965 replica of the bridges that once spanned rivers and creeks throughout the state. They were covered by early builders to protect the wooden trusses from the elements. Lake of the Woods County Park also includes The Early American Museum, Lake of the Woods Golf Course, and a three-mile walking and biking path.

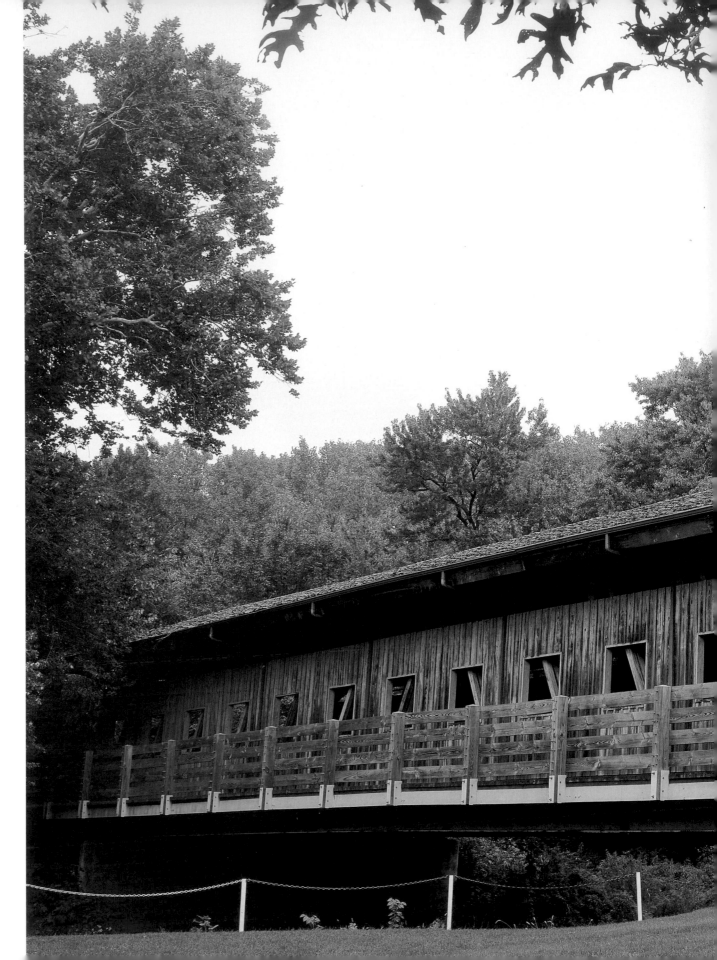

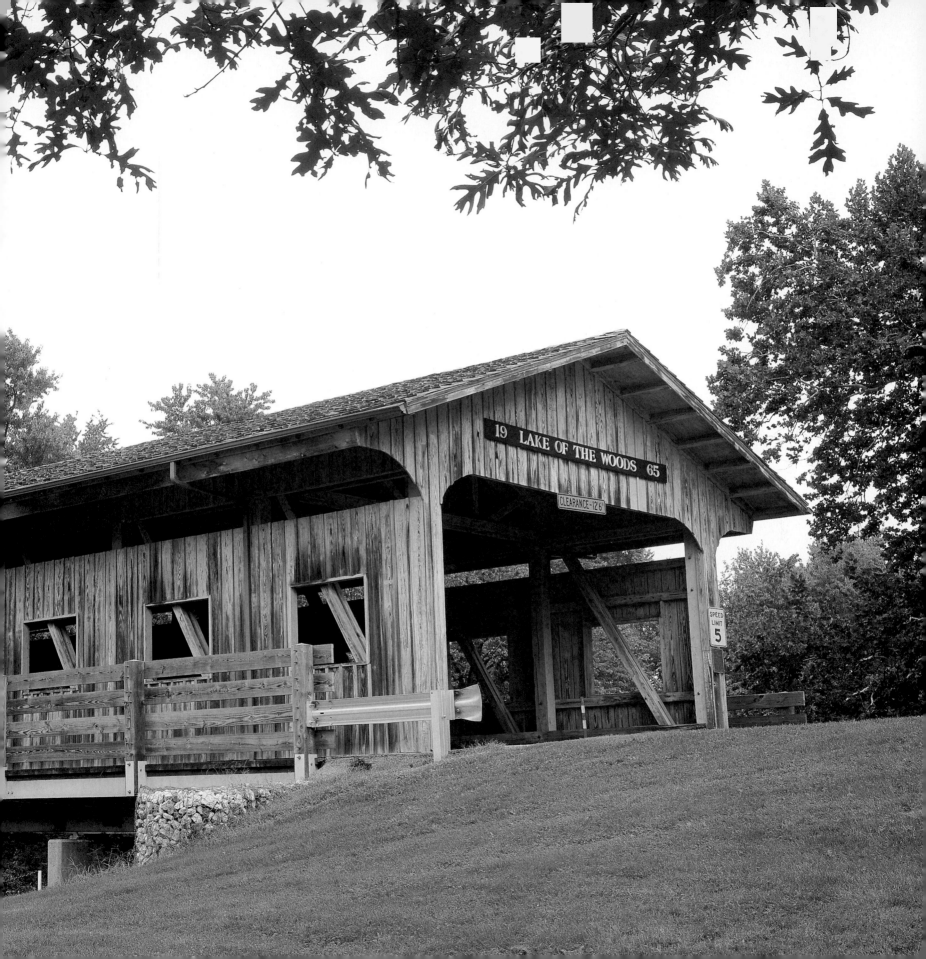

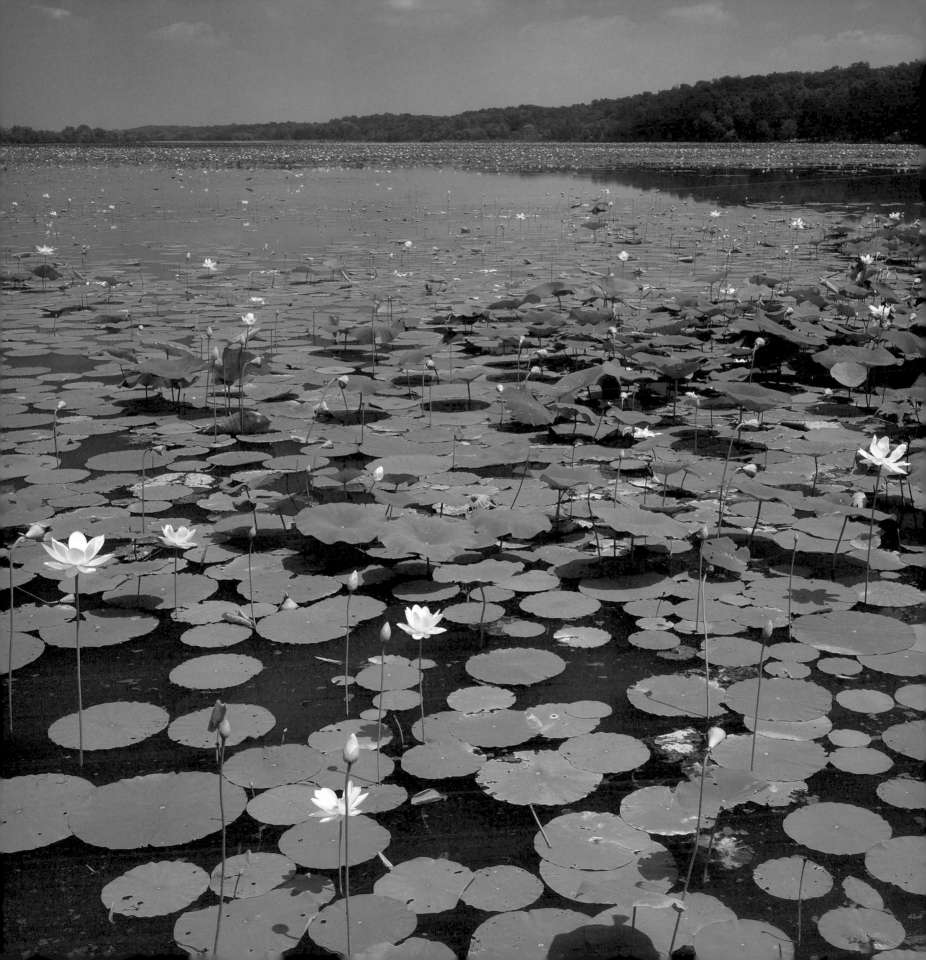

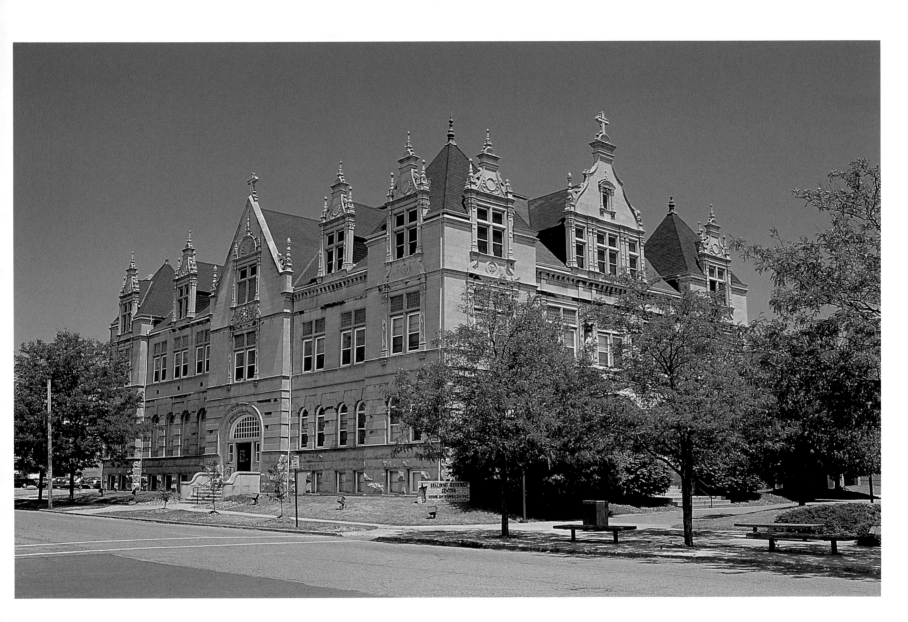

Located halfway between Chicago, Illinois, and St. Louis, Missouri, Peoria is at the heart of the Midwest. When vaudeville companies toured America's small-town stages, managers asked, "Will it play in Peoria?" If audiences here liked a show, audiences everywhere would follow.

The aquatic vegetation that thrives in the shallows of Spring Lake State Park near Peoria provides shady hiding spots for bluegill, which in turn feed largemouth bass. It is the bass that draw anglers to patches of open water each summer, and ice fishers in winter.

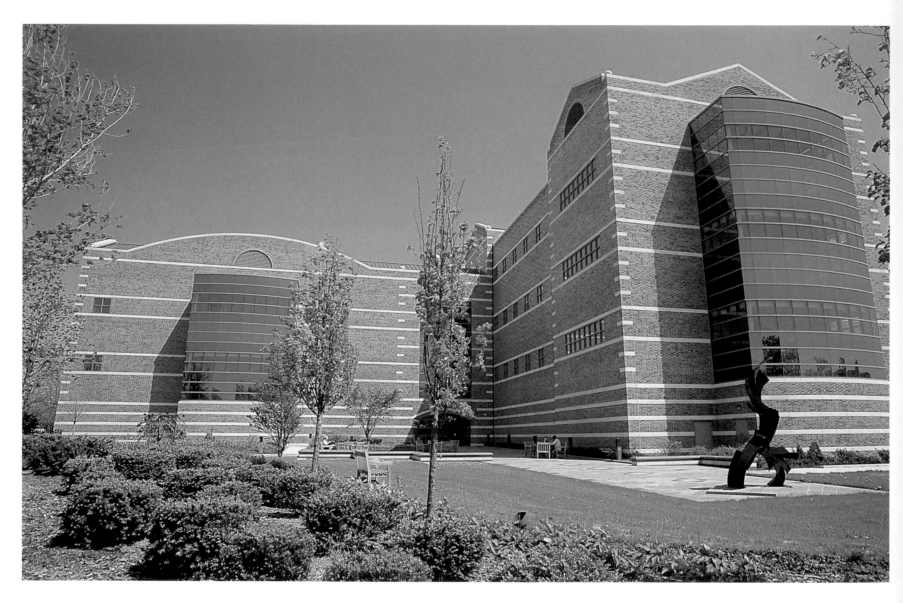

Founded in the 1970s by University of Illinois alumnus Arnold Beckman and his wife, Mabel, the Beckman Institute for Advanced Science supports research in physical science, computation, engineering, biology, behavior, and cognition.

The University of Illinois at Urbana-Champaign was founded in 1867. Funded by private donors in the 1920s, and named to honor students and alumni killed in World War I, Memorial Arena is home to the Fighting Illini football team.

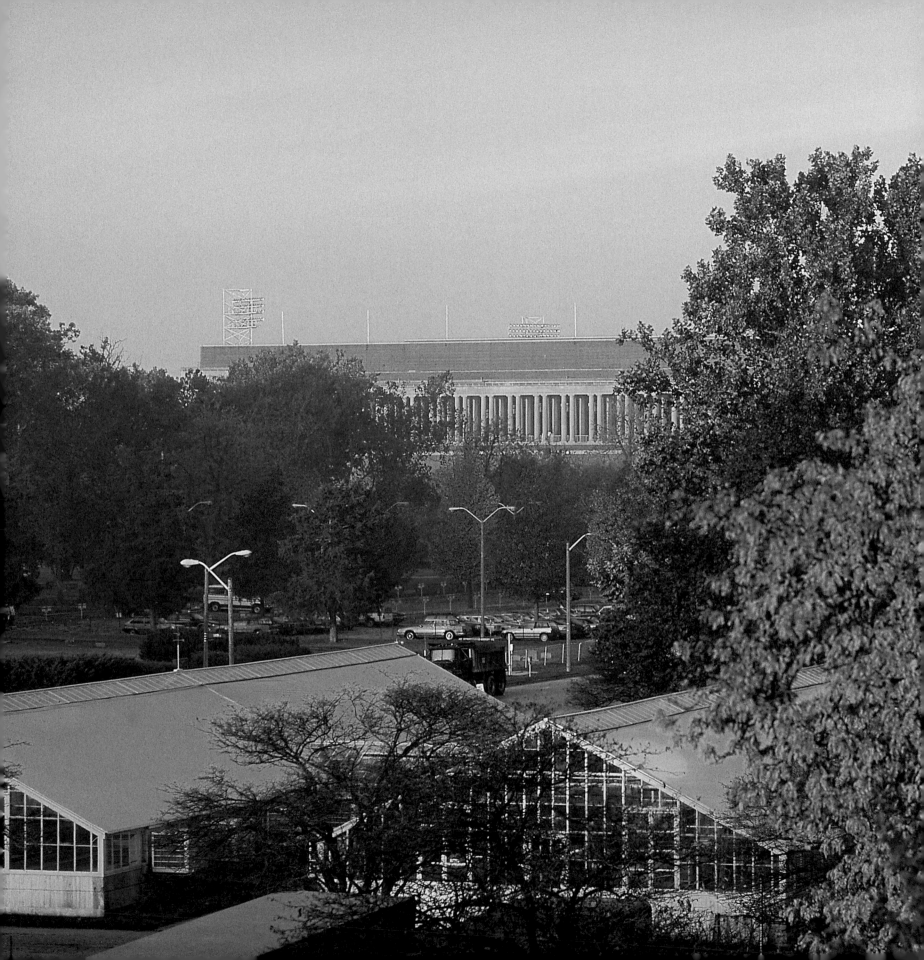

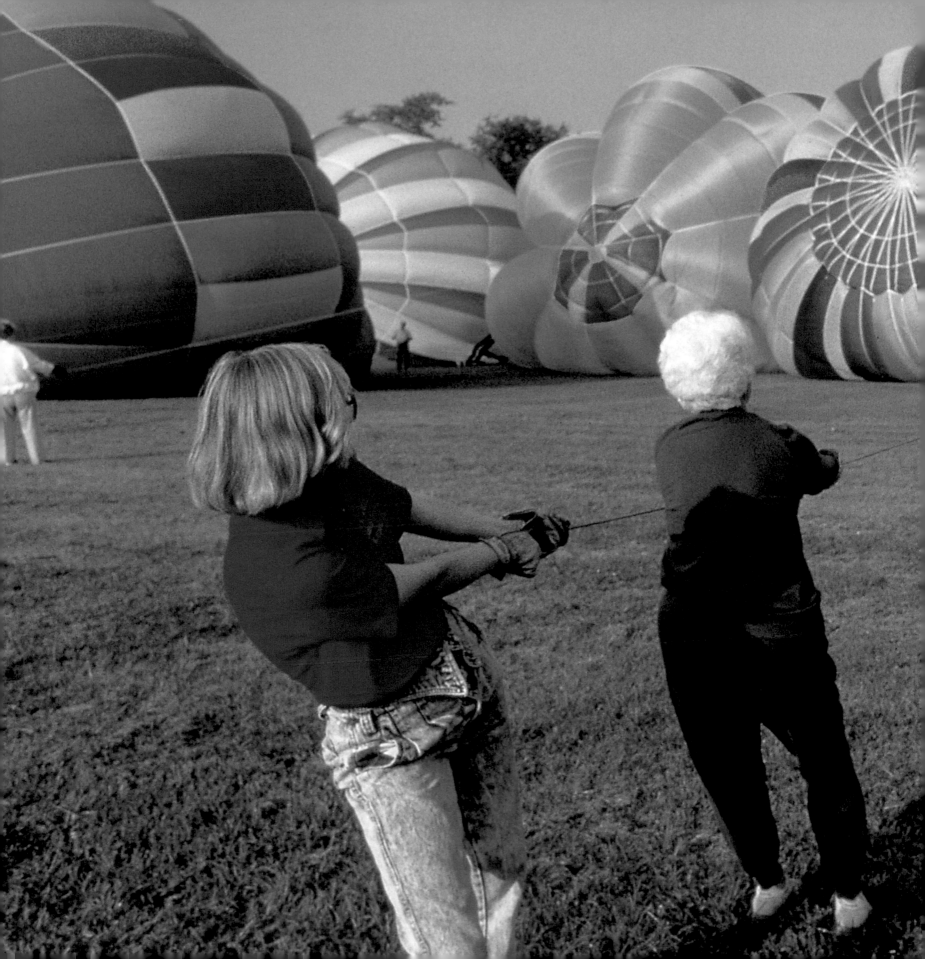

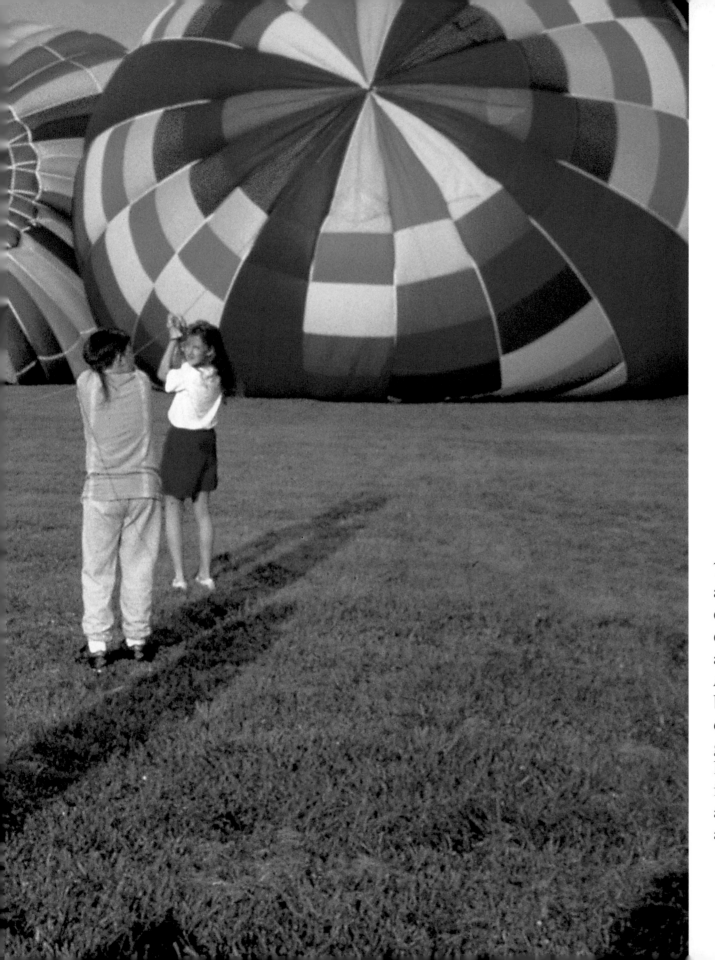

The Lincoln Art
and Balloon Festival
each August attracts
enthusiasts from
across the state.
Along with hot-air
balloon launches and
evening displays of
glowing, rising bal-
loons, the event
includes an art fair,
an antique car show,
a carnival, and more.

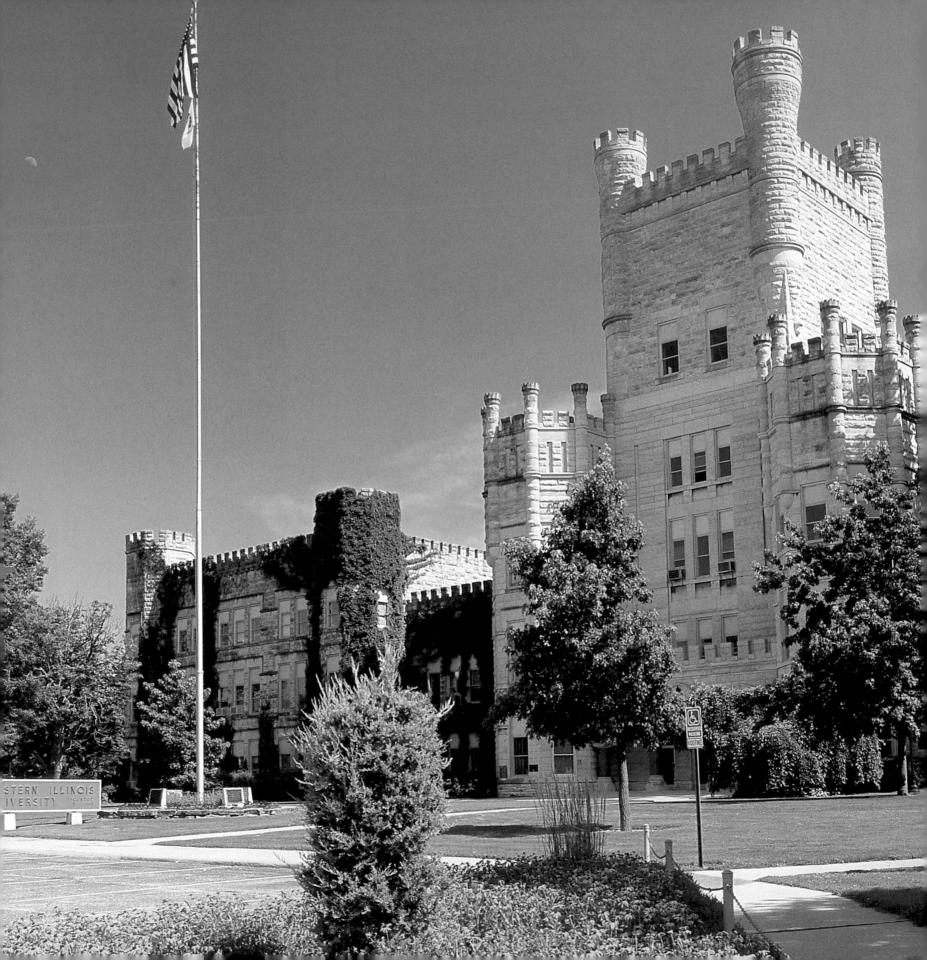

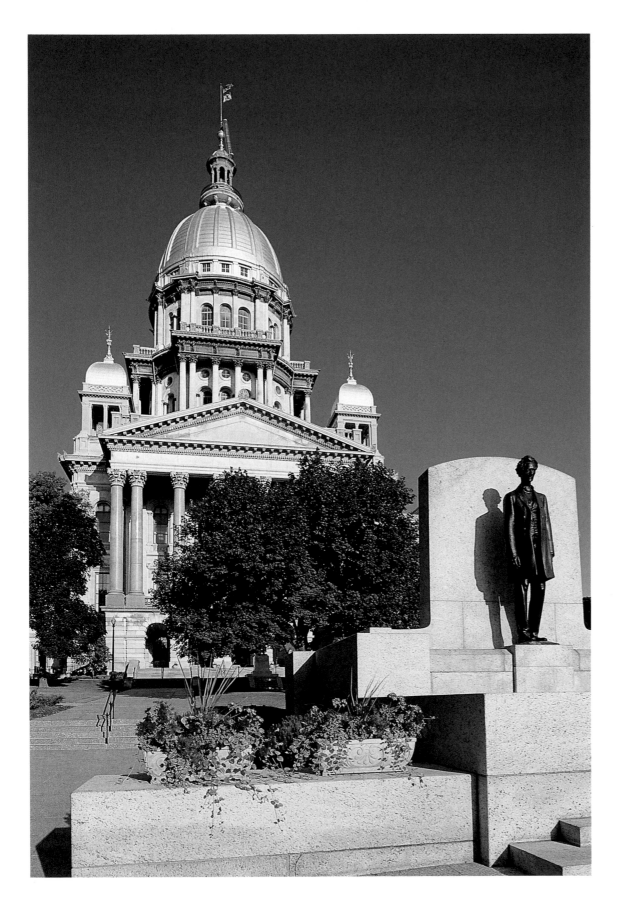

The limestone State Capitol in Springfield was completed in 1888. The 361-foot dome gracing the building reaches 74 feet taller than the dome of the U.S. Capitol. The office furniture within includes the desk, originally from a grocery store, used by Abraham Lincoln as he wrote his first inaugural address in 1861.

FACING PAGE—
With an average class size of 22, Eastern Illinois University in Charleston offers its students individual attention. The Livingston C. Lord Administration Building, built in 1899 and known to students as "Old Main," was named for the university's first president.

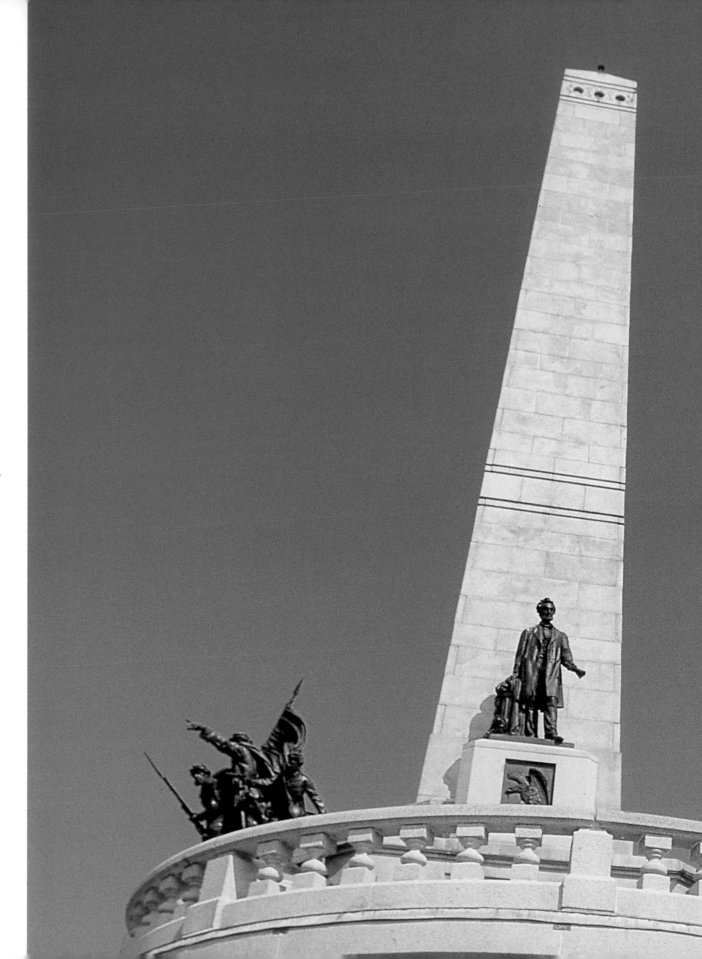

Abraham Lincoln, Mary, and three of their sons are buried at Oak Ridge Cemetery in Springfield. After leading his nation through the Civil War and promising "malice toward none, with charity for all" as his enemies fell, Lincoln was assassinated on April 14, 1865. He was shot by Confederate sympathizer John Wilkes Booth during a performance at Ford's Theatre in Washington, D.C.

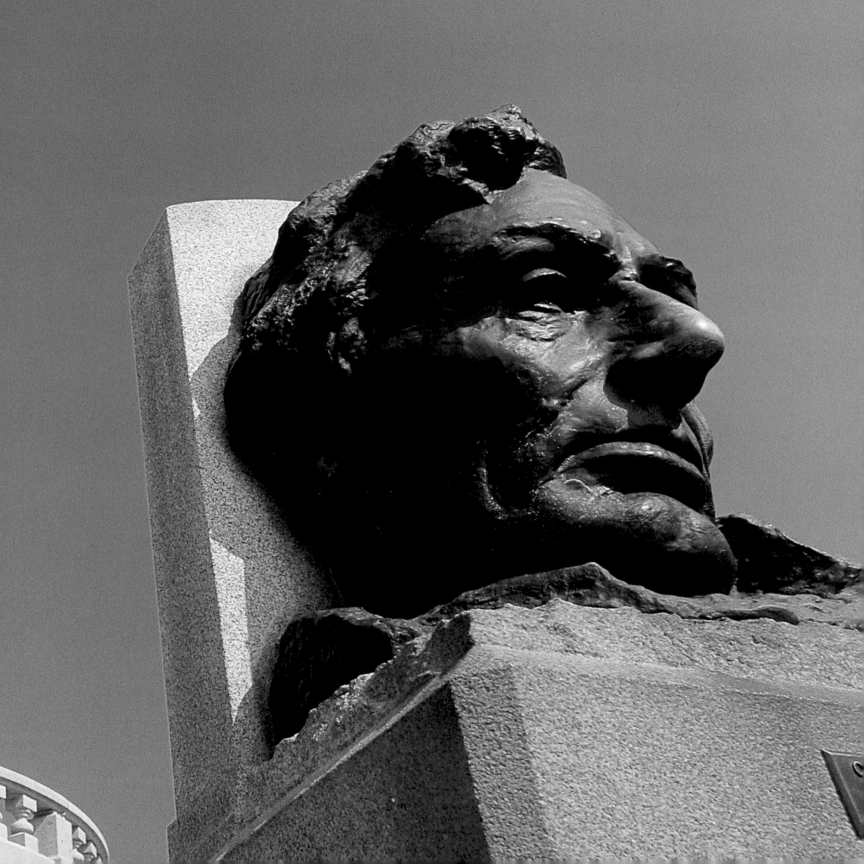

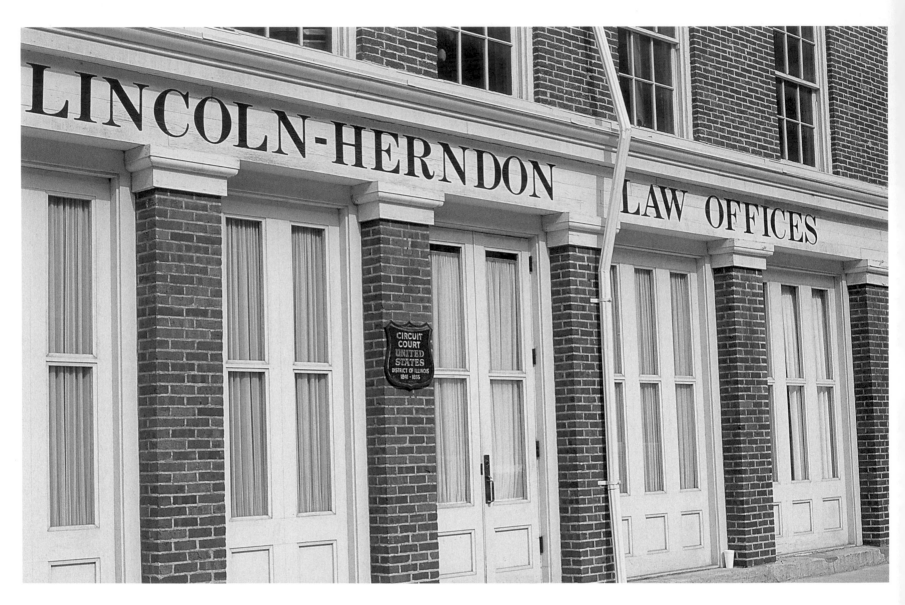

Abraham Lincoln built his reputation as a partner in the Lincoln-Herndon law offices in Springfield. The aspiring politician practiced here from 1843 until 1852. When he was elected president, he asked his partner to keep his name on the sign, promising to return.

Abraham Lincoln and his wife, Mary, lived in this two-story Springfield home from 1844 until 1861 when Lincoln was elected president of the United States. The home and most of the four historic blocks surrounding it remain much as they were in the 1860s.

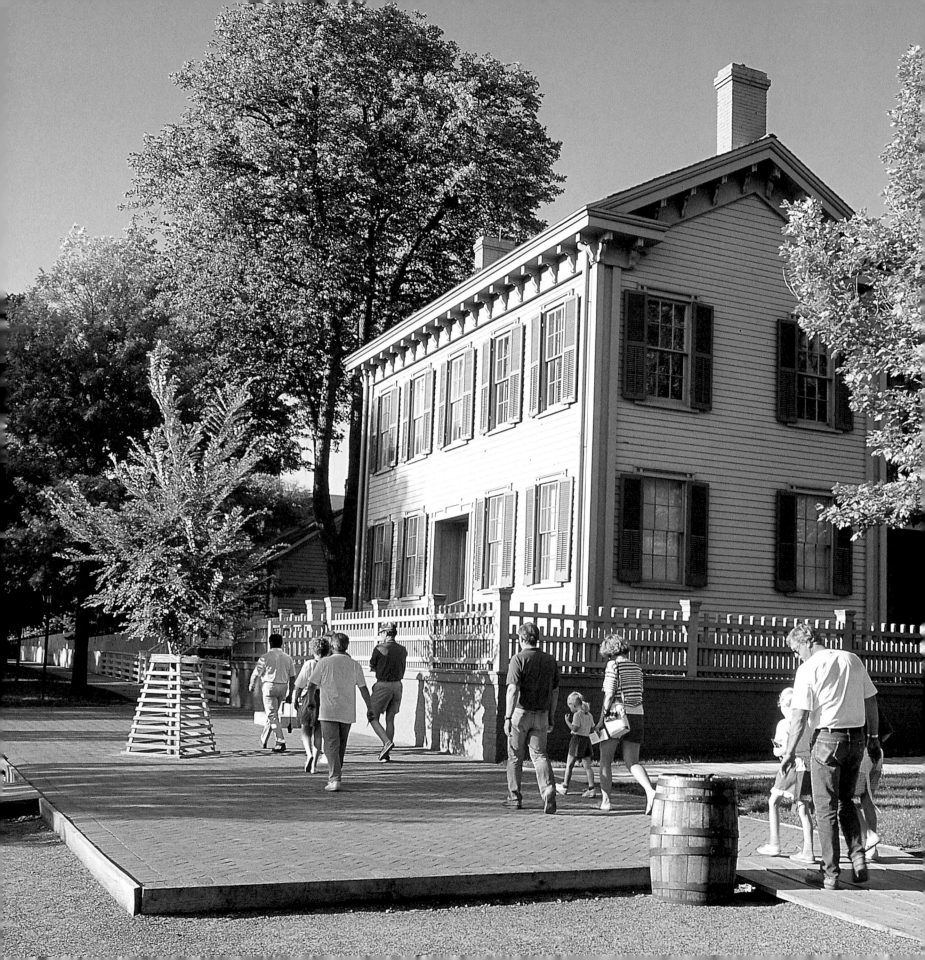

In 1980, Illinois schoolchildren chose the white-tailed deer as the state animal. About 15 million white-tailed deer roam North America, as far north as Canada's Great Slave Lake and as far south as Mexico. The deer are named for the white patches, or flags, on their tails, visible as they leap through the brush.

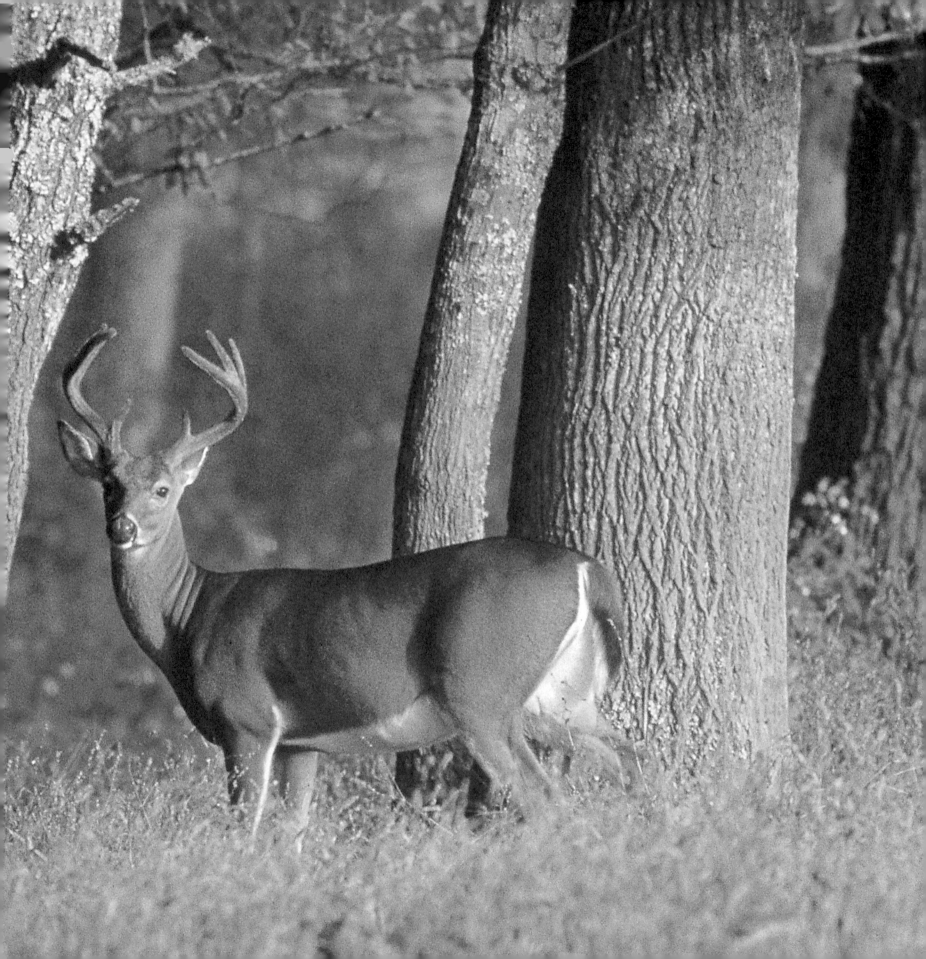

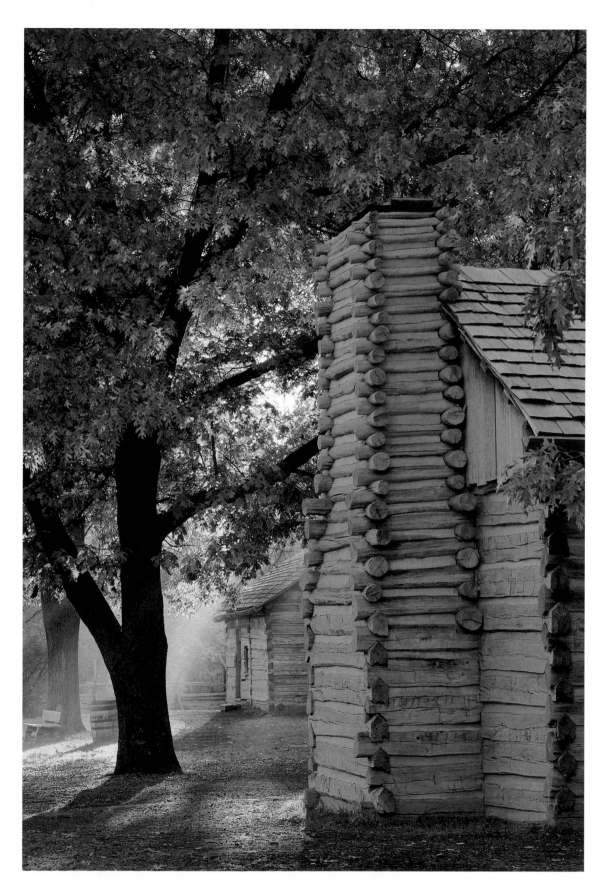

As a young man, Lincoln lived for six years in New Salem, working as a store clerk, laborer, soldier, postmaster, and surveyor. At Lincoln's New Salem State Historic Site, visitors can tour the town as it was in the 1830s, complete with log homes, a tavern, shops, and a schoolhouse.

FACING PAGE—
The largest state preserve in Illinois, Pere Marquette State Park envelops 8,035 acres of archeological sites, native burial mounds, ancient fossil beds, and pristine wilderness. In winter, bald eagles often perch on treetops high above the Illinois River, scanning for fish in the waters below.

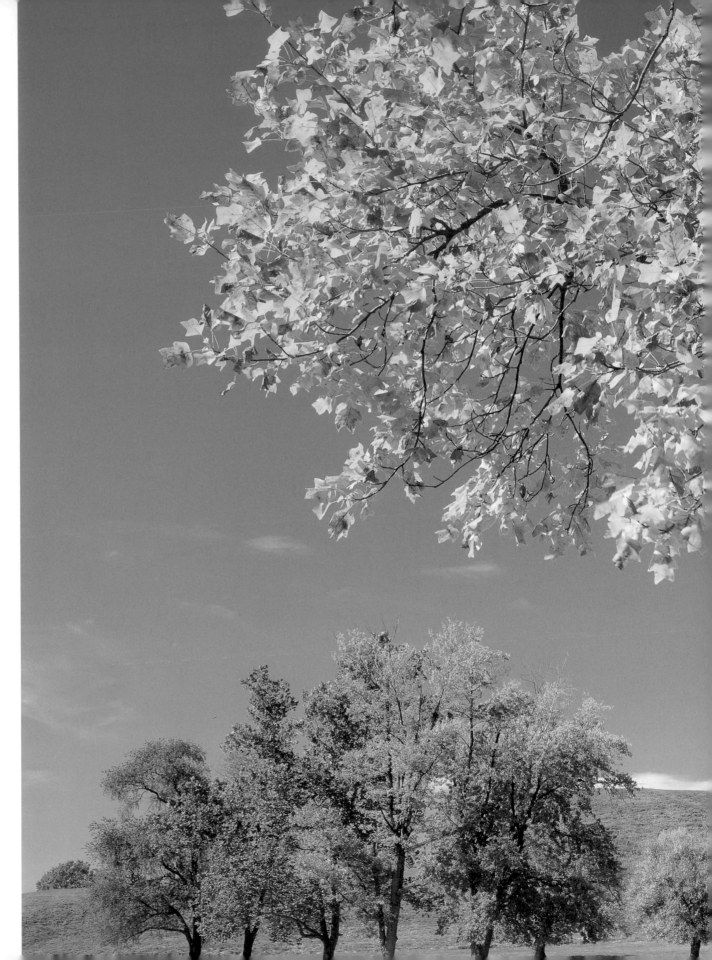

Excavations at Cahokia Mounds State Historic Site have revealed the most sophisticated ancient culture known to exist north of Mexico. Now a UNESCO World Heritage Site, remains from 700 to 1400 A.D. show a six-square-mile city, consisting of rows of houses and open plazas, surrounded by agricultural areas.

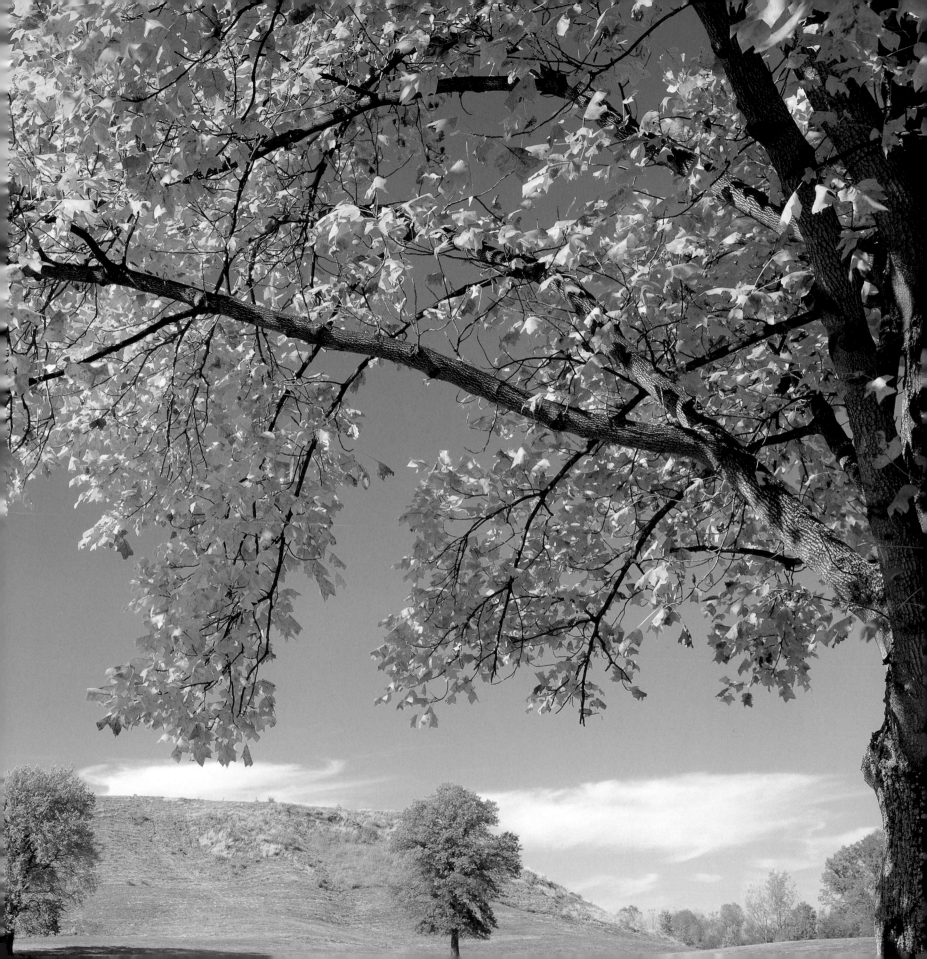

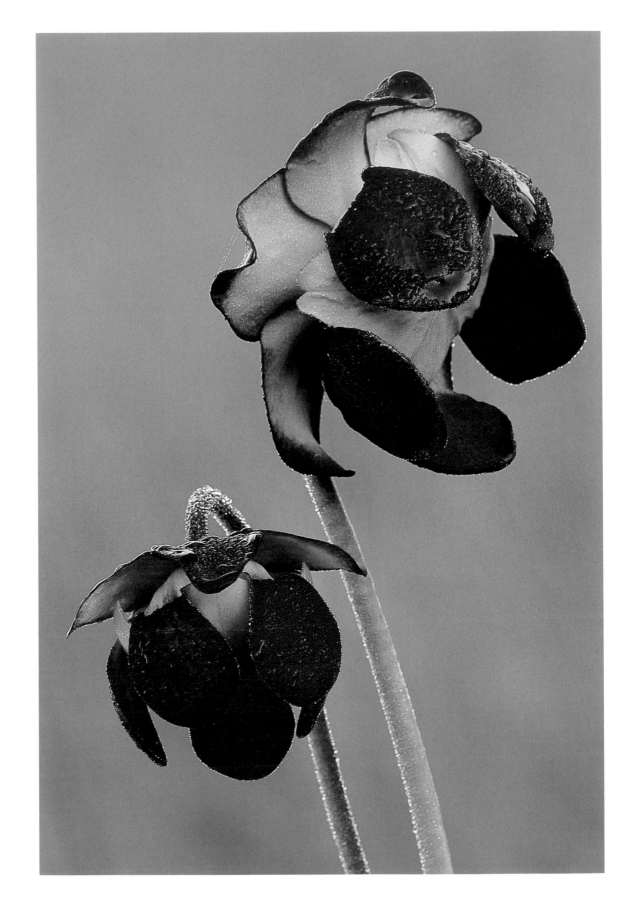

The carnivorous pitcher plant attracts insects with its sweet nectar and vibrant colors, then drowns them in its tube-shaped leaves. Different species of the plant are found in bogs throughout the United States and as far away as Borneo and Australia.

FACING PAGE—
Ramsey Lake State Park— once known as the Old Fox Chase Grounds—was a favorite destination of raccoon and fox hunters. Today, more than 120 camp- sites dot the 1,800-acre preserve and trails wind through the woods.

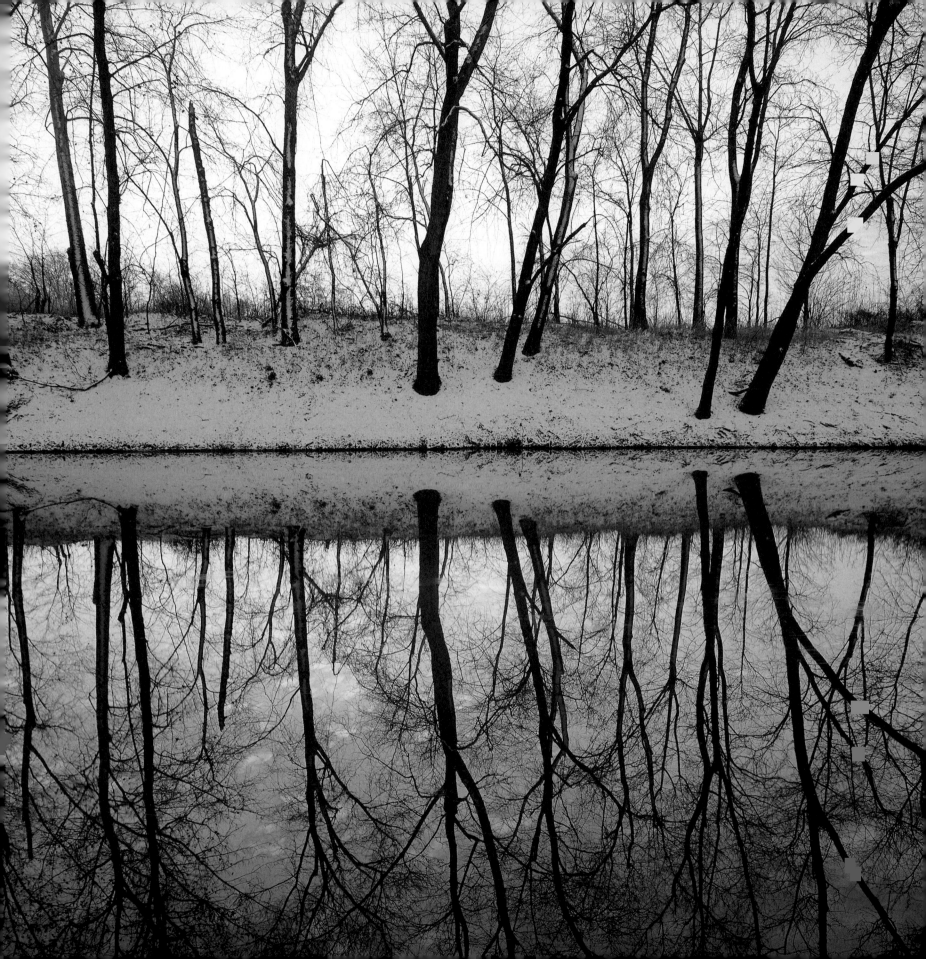

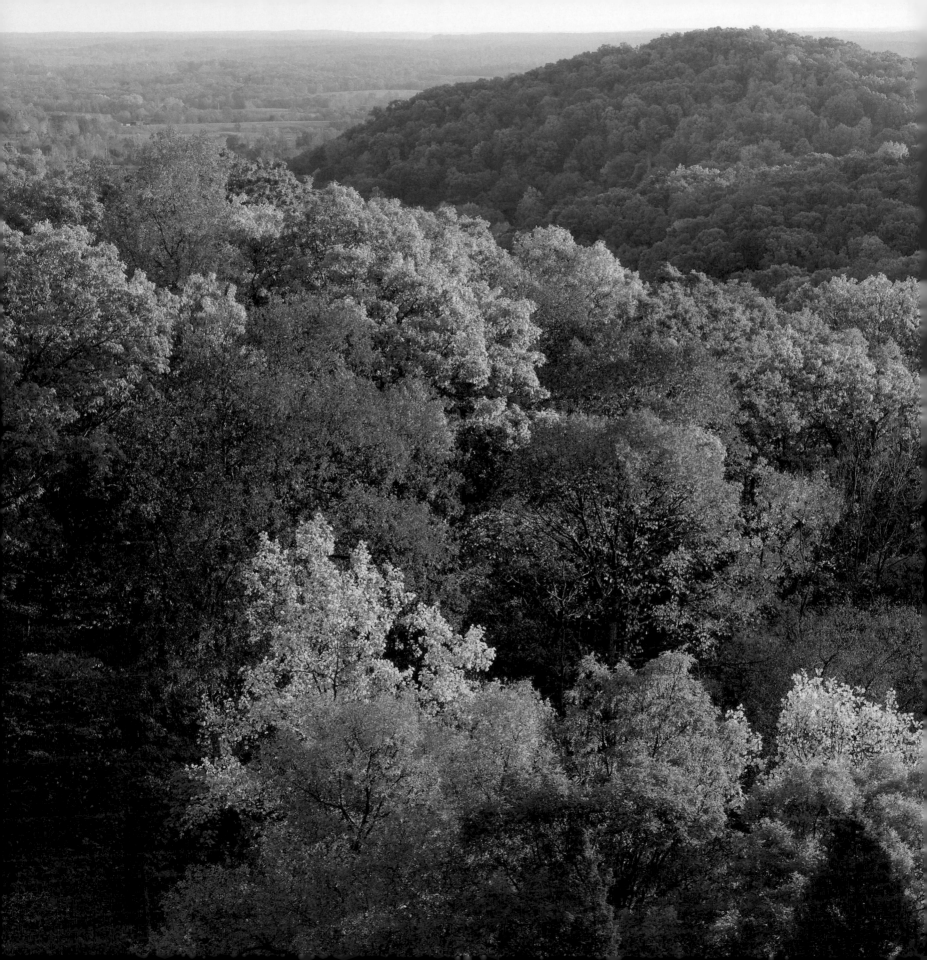

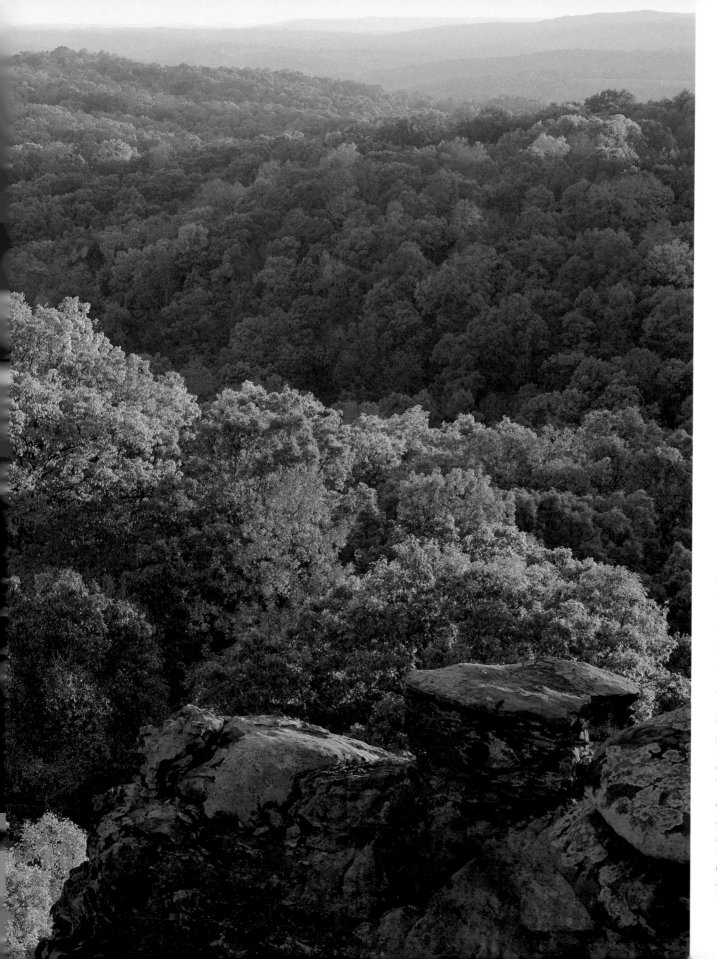

Bordered by the Ohio River on the east and the Mississippi on the west, lush Shawnee National Forest in Southern Illinois is known as the Land Between the Rivers, where awe-inspiring sandstone and lime- stone outcroppings give way to dense wilderness. Some of the forest's most interesting features lie within the Garden of the Gods Recreation Area.

91

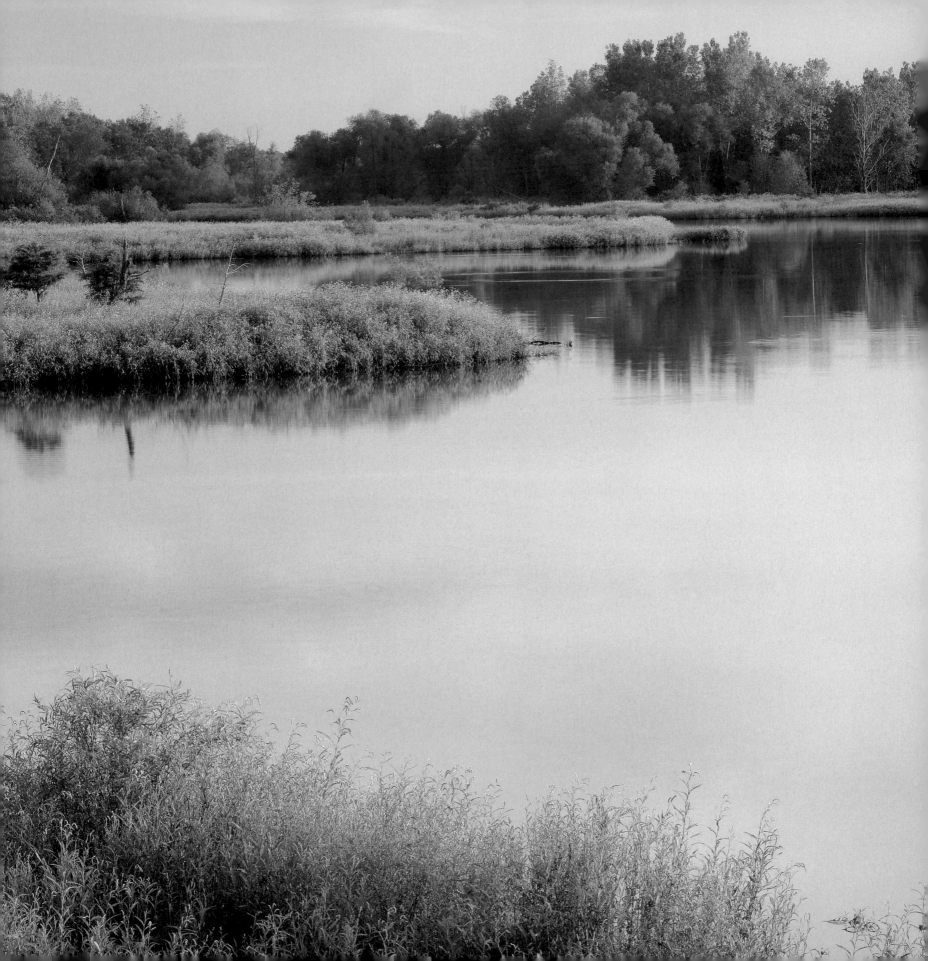

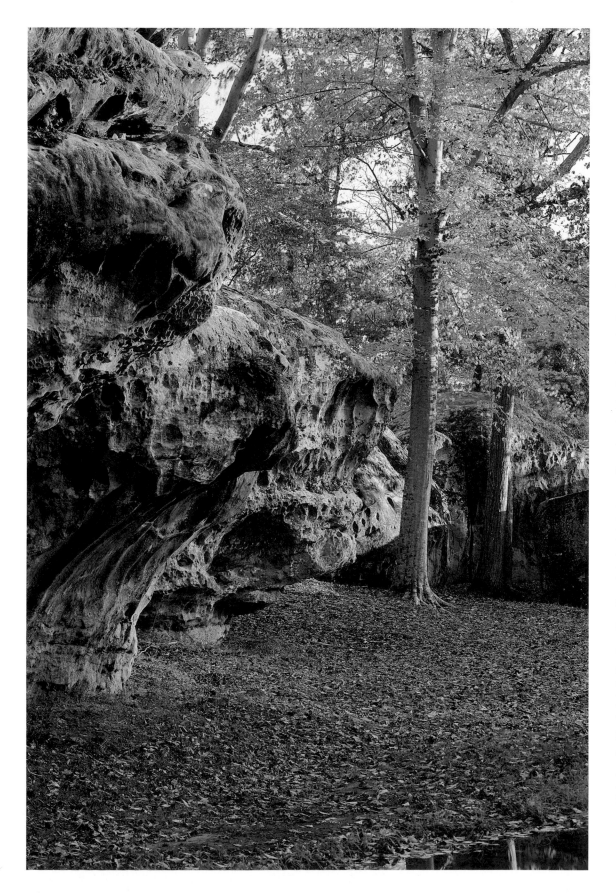

Rugged stone walls mark
a fault line that extends
through Dixon Springs
State Park in the Illinois
Shawnee Hills. The same
fault is responsible for
the nearby mineral springs,
which has attracted tourists
since the 1800s.

<small>Facing Page—</small>
Eldon Hazlet State Park
protects 2,800 acres on
the shores of Carlyle Lake,
an artificial body of water
created when the U.S.
Army Corps of Engineers
completed a dam on the
Kaskaskia River in 1966.
More than 800,000 visitors
enjoy the park each year,
where they find boating,
picnicking, and camping
facilities.

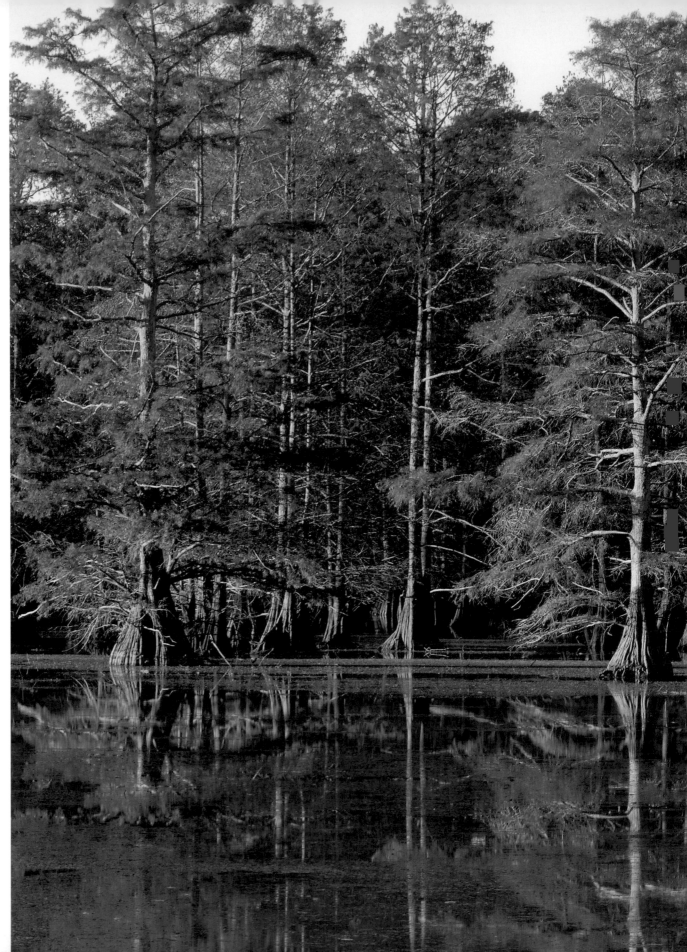

In the low-lying areas of southern Illinois, ancient bald cypress trees dominate wetland preserves such as Horseshoe Lake State Conservation Area. Here, 2,400 acres of shallow water and the reed-choked surrounding shores offer shelter to fish and bird species, including more than 150,000 Canada geese that winter within the park each year.

94

Photo Credits